IMAGES
of America

MAUMEE
OHIO

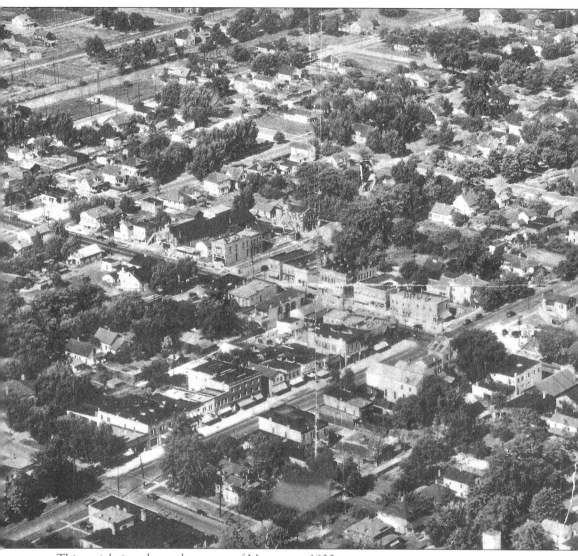

This aerial view shows the center of Maumee c. 1930.

IMAGES
of America

MAUMEE
OHIO

Marilyn Wendler

ARCADIA

Published by Arcadia Publishing,
an imprint of Tempus Publishing, Inc.
3047 N. Lincoln Ave., Suite 410
Chicago, IL 60657

Printed in Great Britain.

Library of Congress Catalog Card Number: 00-107747

For all general information contact Arcadia Publishing at:
Telephone 843-853-2070
Fax 843-853-0044
E-Mail sales@arcadiapublishing.com

For customer service and orders:
Toll-Free 1-888-313-2665

Visit us on the internet at http://www.arcadiapublishing.com

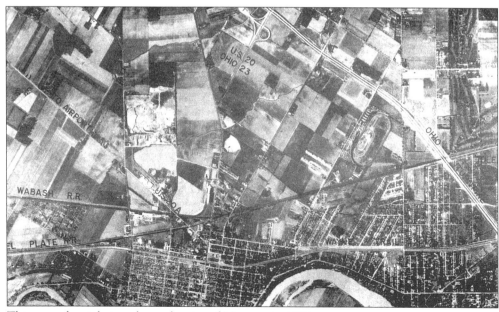

This second aerial view shows the city of Maumee in 1963.

CONTENTS

ACKNOWLEDGMENTS

Many people have been helpful in providing photographs for this book. I am particularly grateful to Jack Hiles, who generously loaned me photographs from his extensive collection of Maumee memorabilia. My thanks also to the family of David and Mary Morris, whose albums provided a wealth of early Maumee history. Others who contributed were Ben Marsh, Isabel Martin, Barbara Dennis, Kent and Beverly Botte, Marty and Jacky Pauken, Dale Fallet, Tom Brell, Barney Stickles, Andrew Wendler, Nancy and Joseph Hendrikx, City of Maumee, Lucas County/Maumee Valley Historical Society, Center for Archival Collections, BGSU, Toledo/Lucas County Library, the Andersons, the *Blade*, and the *Mirror*. Old newspaper clippings from the now defunct *Maumee Valley News* were also helpful. The remainder of the photographs have been entrusted to me, as Maumee historian, over a period of years, so it has been a pleasure to include them in this volume. I also am deeply grateful to my husband, Pete, for trudging patiently to historic sites, assisting with photography, and enduring my frustrations.

INTRODUCTION

Maumee, Ohio, situated on the banks of the Maumee River at the foot of the rapids, and early home to prehistoric and historic Native American tribes, ultimately attracted eastern speculators and settlers seeking new economic opportunities in the west. A "city" was platted in 1817, and gained notice that year only as a "post town." A decade later, the editor of the *Ohio Gazetteer* looked with increased interest at the settlement at the head of river navigation, noting the recent construction of several stores and a hotel. This led him to predict, accurately it would prove, that "if the projected Wabash and Erie Canal would connect at this point, there was no doubt that this would be an important town."

From the beginning, the Maumee River was the focus of Maumee's economic activity. Its emergence as a major ship building center and river port on the Great Lakes encouraged eastern entrepreneurs to flock to the area. The construction of the canal and Maumee's designation as a terminus contributed to a mad frenzy of buying and selling lots, resulting in fortunes made and lost overnight. During these hectic days, Maumee was touted as the "Future Great City of the West" and gained the custom house, federal post office, and was designated as the county seat of justice. However, Maumee faced a formidable rival in neighboring Toledo, and by mid-century had lost the economic and political races to the faster-growing city. This, in a sense, was a fortuitous turn of events.

Instead of a rapidly growing city with ever-changing boundaries and landmarks, Maumee became a sleepy village virtually untouched by time for over a century. The rituals, ceremonies, patriotic fervor, and everyday life of the residents were typical of small towns throughout the Midwest. All of that would begin to change after World War I. Innovations in technology, beginning with the introduction of the interurban electric railway at the turn of the century and culminating with the availability of the automobile, would bring in a flood of new residents. In 1952, Maumee received a city charter and community leaders spoke enthusiastically of progress and growth. Unbridled expansion would be regulated through a master plan and municipal guidelines for construction and industry. In the 1980s, forward-thinking civic leaders envisioned the concept of a carefully regulated industrial park, resulting in Arrowhead Park, a model industrial and commercial community, and encouraged the

construction and expansion of St. Luke's Hospital, a highly regarded medical facility.

As the village grew, the role of the river, which had given birth to Maumee's early economic life, changed accordingly. Private homes now stretch along the shoreline where bustling warehouses and river docks once lined the banks. Pleasure craft cruise the river where once only the solitary "bark canoe or pirogue of the voyageur" stirred its surface and the great schooners and steamboats were proudly launched from the shipyards amid the cheers of the crowd and the salute of cannons. However, when a strong westerly wind lowers the level of the river, the remnants of the old docks are visible below the surface, a fleeting reminder of the brief importance of the "Maumee trade."

It would be impossible to include every significant event which has taken place in the past two hundred years or to recognize the contributions of all of the many people who have played a part in Maumee's history. Much of that history was covered in my earlier work, *Foot of the Rapids: Biography of a Rivertown*. In this book I have attempted only to highlight some of those events and people going about their everyday lives, and to follow the development of the village with its successes and setbacks on its journey toward city status. As Maumee enters the 21st century, the evidence of vast commercial and residential growth is apparent, but it has managed to keep its "small town" image as a great place to live, work, and play. Some might even agree with the early visionaries who pinned their economic aspirations on Maumee and predicted that "a great city" would someday arise in the wilderness at the foot of the rapids.

One
STREETSCAPE
THEN AND NOW

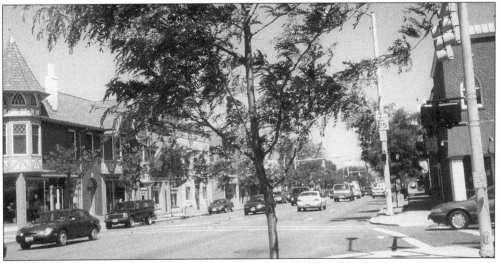

New sidewalks, street lighting, trees, and plantings are all part of Maumee's streetscape program begun in the 1970s, and which is regularly upgraded.

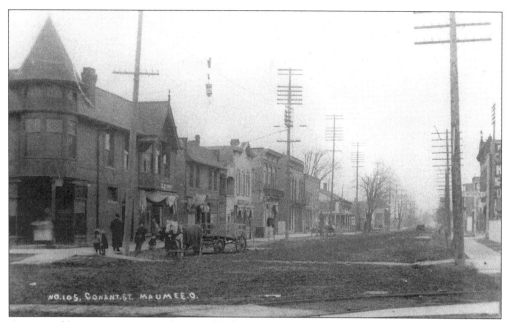

A team of horses waits patiently outside the Union Deposit Bank at Conant and Wayne, c. 1900. This block of Victorian buildings with their wide cornices and heavy lintels still stands, relatively unchanged. The American House, razed in 1936, is beyond Dudley Street, opposite Bigley's Hardware.

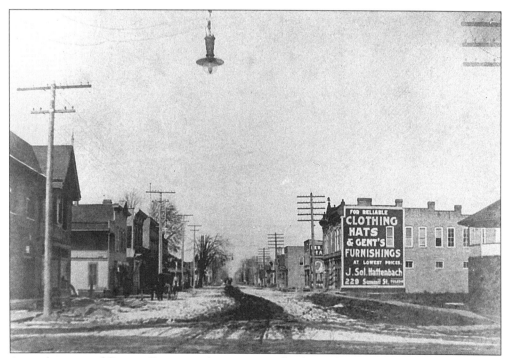

An earlier view of Conant Street, on the opposite side, shows the Henfling Building sporting a two-story advertisement for a Toledo clothier. The interurban car is approaching the corner on the right.

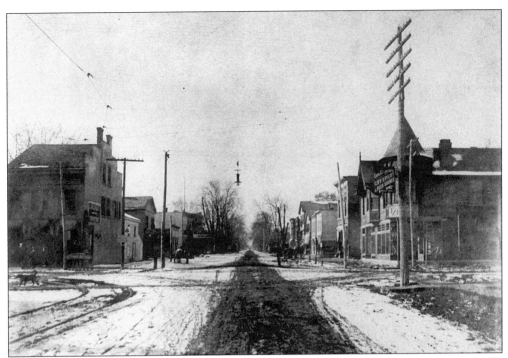

This view looks to the right down Wayne Street, beyond Eckert's and the Union Deposit Bank, anchoring their respective corners.

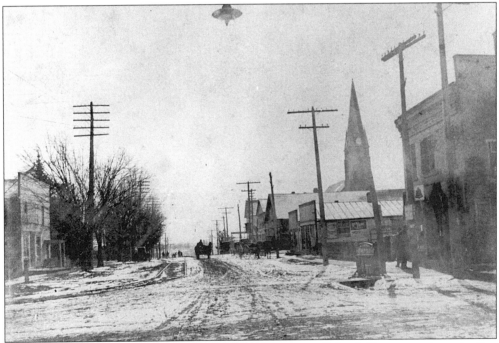

Traveling toward the Maumee-Perrysburg Bridge, one passes Eckert's Drugstore where the first public telephone was located, as indicated by the American Bell sign. The spire of St. Joseph's Church looms in the background.

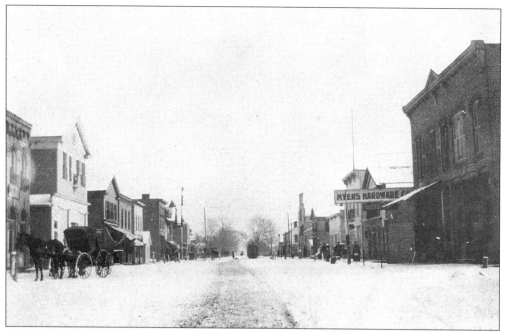

A view from the opposite direction of Wayne Street shows the old Masonic Hall, second from the left. Many community celebrations, including graduation ceremonies and live theater performances, took place in this building. The hall, built in 1827, was one of the last examples of Greek Revival commercial architecture. It was moved across the street in 1916, and was finally razed in 1937.

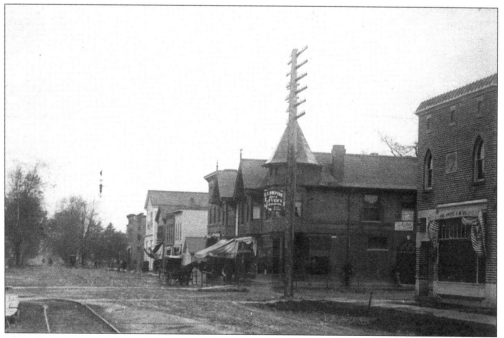

This photo shows a later view of W. Wayne Street, with the Roller Saloon (built in 1902) at the corner of E. Wayne and Conant Streets.

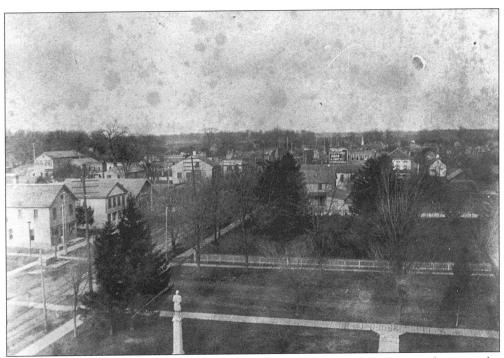

Two views from the belfry of Union School give a bird's-eye look at the center of town in the early 1900s. Note the large area of open space. Residents once gathered here on warm summer evenings for concerts presented by the community band in a portable bandstand. The Soldier's Monument is prominent in the upper photo, and the Presbyterian Church stands out in the lower. Pilliod's Island can be seen in the background.

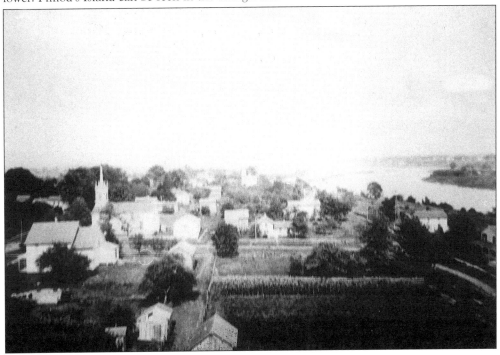

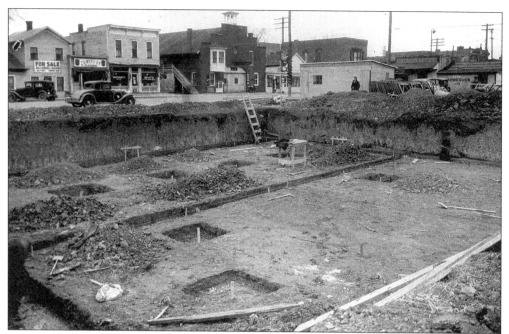

Construction was begun on a new post office in 1937. Several buildings at the north end of Conant Street, which no longer exist, are visible. To the right in the upper photo can be seen the top floor of the I.O.O.F. building housing the post office. A lunch room advertises "barbecues" for 10¢. A gas pump stands in front of Sheperd Garage (formerly livery) and lunch stand (center). Sanitary Cleaners is between Pfleghaar Brothers Grocery and the former Pfleghaar home. To the right in the lower photo is Renaux's Maumee Restaurant and Hotel. Johnson's Gasoline Station is at the corner of John and Conant Streets.

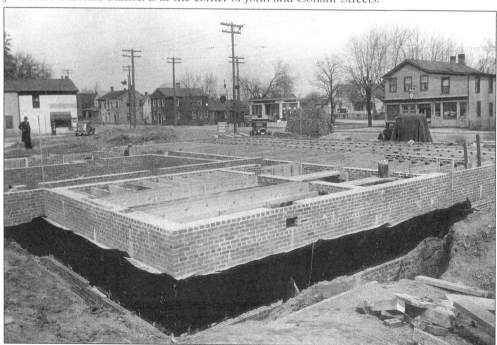

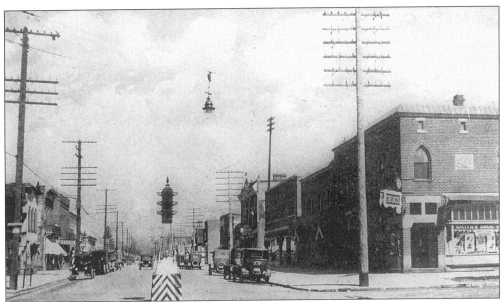

Maumee's earliest traffic signal stands duty at the corner of Wayne and Conant Streets. Smith's Drugstore is located in the corner building formerly occupied by Roller's Saloon. The neo-Gothic windows of the 1902 building provide a contrast to its more elaborate Victorian neighbors.

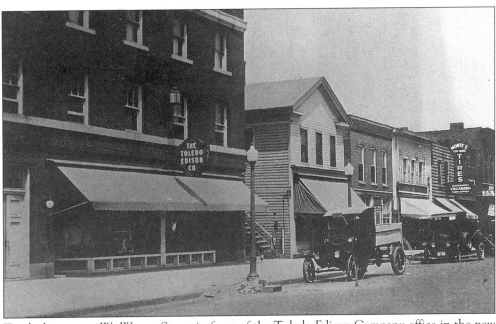

Trucks line up on W. Wayne Street in front of the Toledo Edison Company office in the new Masonic Temple. To the far right is Monte's Auto Supply and Tait's Shoe Repair, *c.* 1930.

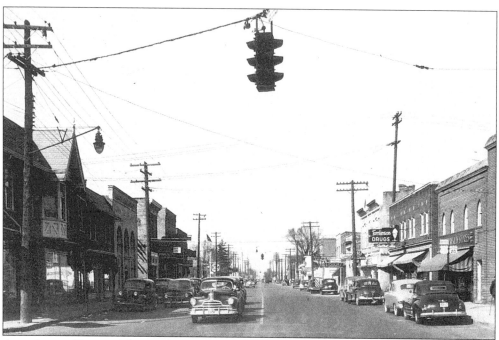

A modern traffic signal directs the increasingly heavy traffic along Conant Street in the 1940s. Wagonlander's Ben Franklin Store (also fronting Wayne), Pauken's Corner Drug Store, and Tomlinson Drugstore are on the right.

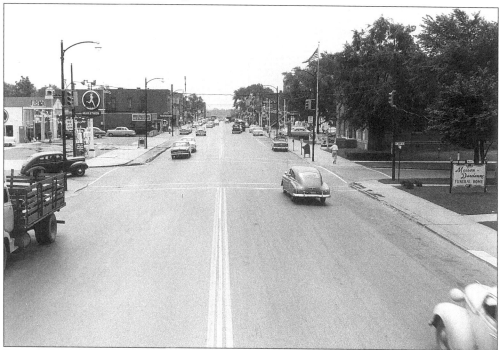

Traveling south on Conant Street in the 1950s, one passes the new Maison-Dardenne Funeral Home and the U.S. Post Office. A used car lot is across Dudley from Bigley's Hardware (on the corner). The Cottage Restaurant is across Conant, beyond the Marathon Station.

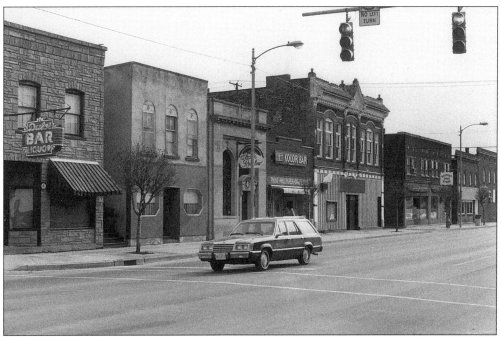

A view of the east side of Conant Street in the early 1970s reveals an increased number of "saloons" occupying former retail space as shopping centers drew customers away from downtown. Many of the buildings were "modernized" during the seventies with additions of fake facades which obliterated the original architectural features.

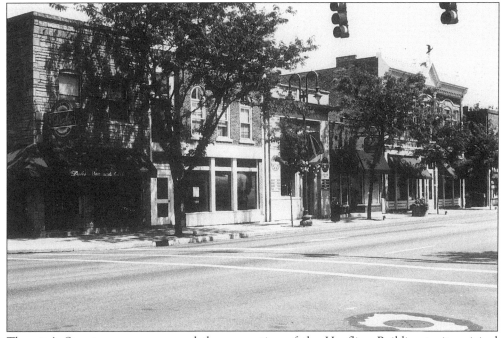

The city's Streetscape program and the renovation of the Henfling Building to its original grandeur sparked a movement to restore buildings along Conant Street. By 2000, almost all of the buildings had been restored.

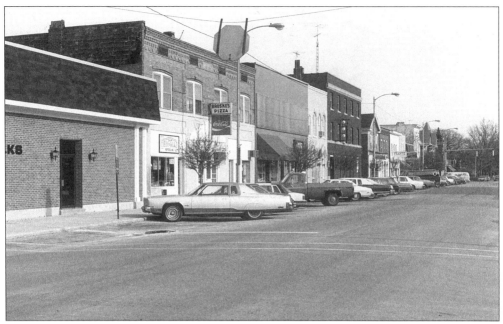

Several century-old buildings on W. Wayne Street were also "modernized" and their architectural features hidden behind fake siding and glass tile fronts.

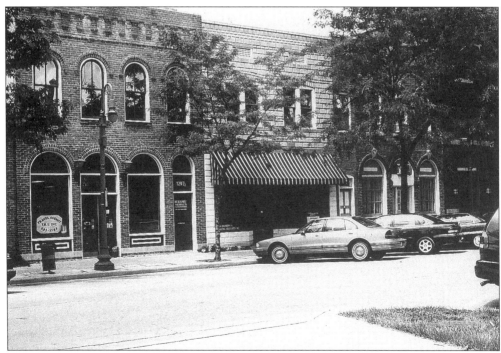

Several unsightly fake facades were removed from these Wayne Street buildings to reveal their original Victorian features.

Two

THE CHANGING FACE

OF BUSINESS AND

INDUSTRY

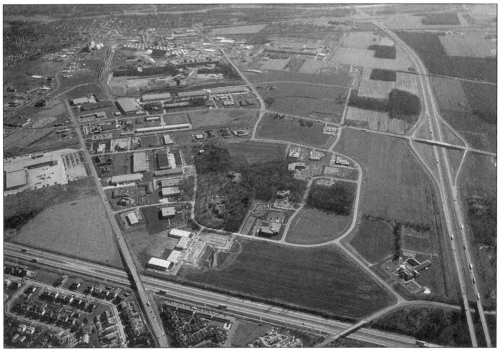

Arrowhead Park, a landscaped industrial and commercial area, was envisioned in the 1970s and became a reality in the 1980s. It houses small industries, warehouses, and medical facilities in a wooded setting with motels, restaurants, and service-oriented businesses nearby.

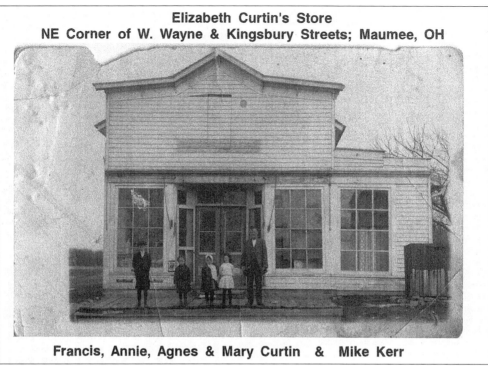

Elizabeth Curtin's Store
NE Corner of W. Wayne & Kingsbury Streets; Maumee, OH

Francis, Annie, Agnes & Mary Curtin & Mike Kerr

Elizabeth Curtin sold "groceries and provisions" in her store at the corner of W. Wayne and Kingsbury Streets as late as 1918. Pictured are, from left to right: Francis, Annie, Agnes and Mary Curtin, and Mike Kerr.

Incubators, hatchers, dressed poultry, and baby chicks could be purchased at the Maumee Feed Store on W. Wayne Street. This was the meeting place of the Maumee Poultry Fanciers Club. The poster in the window advertises "Bringing Up Father" at the Valentine Theater. Henry Mattewson, proprietor, pauses in the doorway.

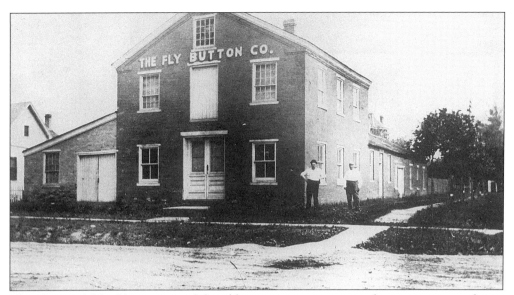

The "Buttergilt" building is one of the oldest remaining commercial structures in northwest Ohio. Edward Mitchell operated a foundry, turning out buggies and agricultural implements in the 1840s. During the 1870s, William Swan invented the "Fly Button," guaranteed to get rid of flies and ants, and manufactured the poison here.

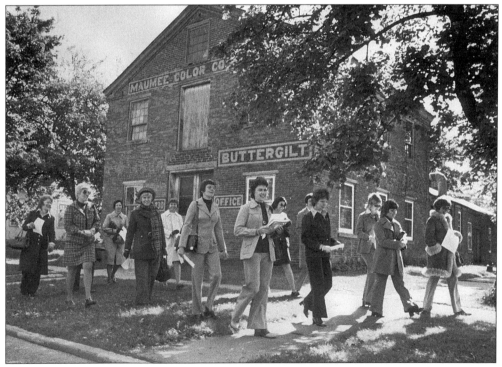

A.F. Files purchased the building in 1923 and developed his process for coloring oleomargarine. The product became immediately successful during World War II and was distributed nationally. The building is noted for its history and architecture, and is often a highlight of tours of the Maumee architectural area.

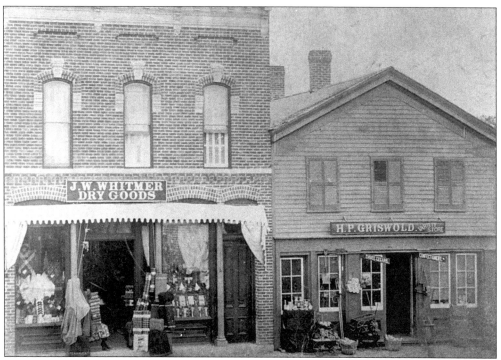

J.W. Whitmer and Harvey "Peck" Griswold's Variety Store offered a wide range of merchandise from children's wagons to choice cigars at their shops on Wayne Street.

Mr. and Mrs. James Kerr operated a tailoring shop here for over 50 years. It was purchased by Preston Baggett in 1936, who operated it as a barbershop. It served the tonsorial needs of several generations of Maumee men and boys for another 50. It has recently been restored.

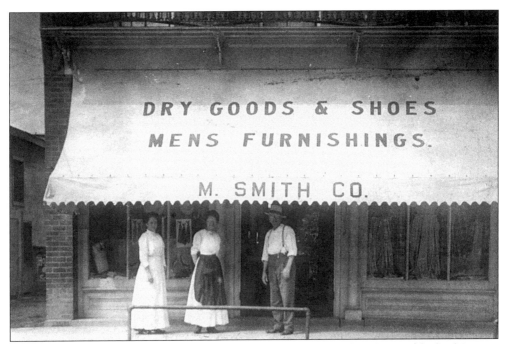

Mrs. Smith's Dry Goods Store (later Puhl's Hardware) was located in the 300 block of Conant Street. Ladies' dresses are displayed in the window.

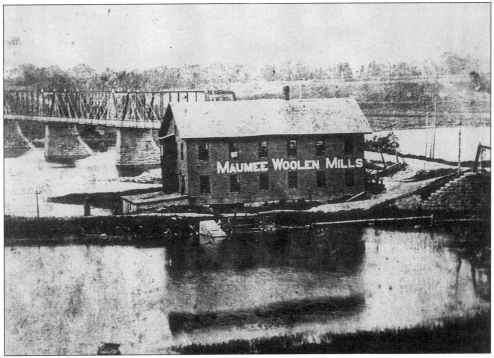

The Maumee Woolen Mills were located on the flats near the bridge. It was operated by the Lautzenheiser family and produced "satinettes, jeans, tweeds, blankets, and knitting yarns" from the post-Civil War period through the late 1900s.

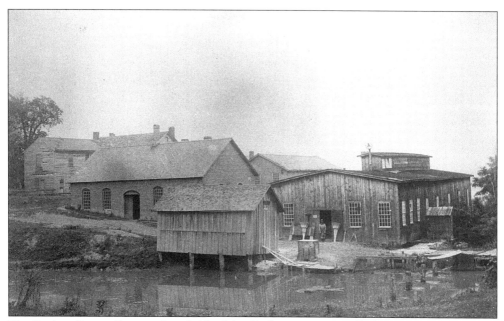

The Pauken Broom Factory, founded by John Pauken, was originally located between Wayne and Broadway, where it could utilize the water from the mill race. Broom samples are displayed by the door (top). It was later moved to Cass Street where the building stands today. Pauken's factory manufactured broom products for both domestic and industrial use. Pauken's son Bernard designed much of the equipment being used by these workers (below).

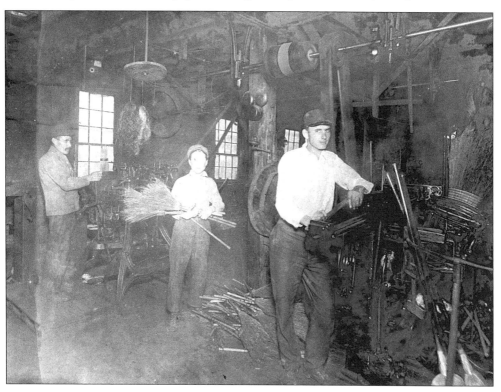

The discovery of natural gas in 1887 attracted out-of-town investors and raised the hopes of local businessmen. In the 1890s, a glass factory was built on W. Sophia Street, and Belgian glass blowers were brought to Maumee. The workers eventually purchased the company and operated it until it was purchased by Case and Merry, with Harry Bamford as manager. Crown Window Co. took over in 1911, and it continued to operate off and on until World War I.

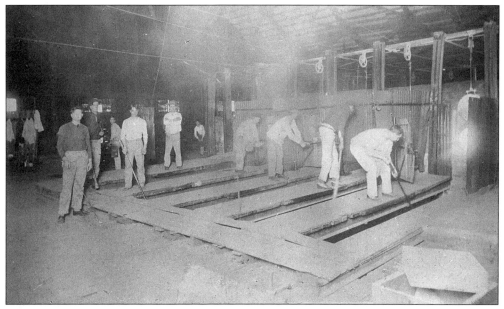

Glass workers Bert Blair, Frank Beach, Jean Dufour, and blowers Leon Botte, John Botte, and an unidentified man are shown at work in the glass factory. Blowers were at the top end of the wage scale, and ranked above flatteners, gatherers, cutters, and gaffers at the bottom.

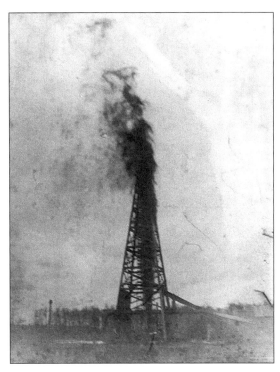

Promoters pinned their hopes on this gas well, located between Maumee and Waterville to bring them prosperity, but, like the others, it went dry within a few years.

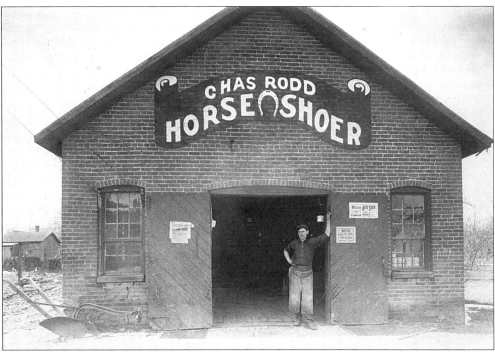

Maumee supported numerous horse-related industries well into the 20th century, as some families hung onto their family steed. With the increasing popularity of the automobile, many blacksmiths would trade their anvil for mechanical skills or learn a new trade. The sign on the door of Robb's blacksmith shop is promoting the Toledo Auto Show.

Seigle Tate began his business career as a saddle maker. By the 1930s, he switched to making and repairing shoes in his Wayne Street shop.

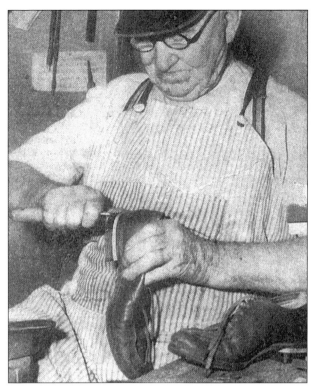

A.B. Coffin, who operated Coffin's Livery and Stable, was also an undertaker, as evidenced by the hearse and casket. The Livery was purchased by George Sheperd, and it became a makeshift fire house for the first fire engine. Mrs. Sheperd sometimes rang the fire bell. Later, it was converted into a garage.

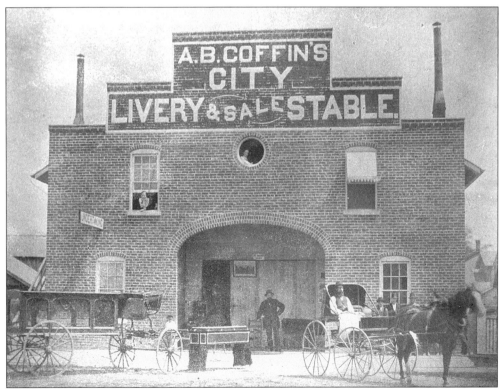

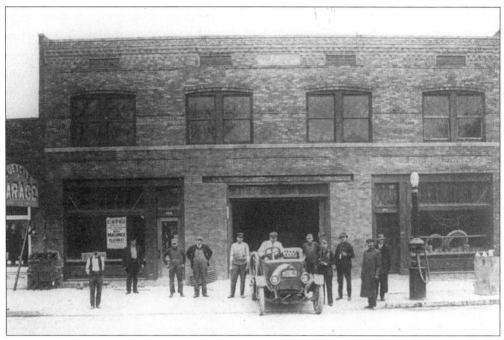

In 1911, Fred Loesch bought the Schier livery stable on W. Wayne Street and converted it into one of the first auto garages. Within three years, he had acquired the first Ford Agency in northwest Ohio and sold the first Ford in town (top). The business expanded into larger quarters at the corner of Wayne and Allen Streets where he and his sons, Louis, John, and Karl, could also service automobiles (below).

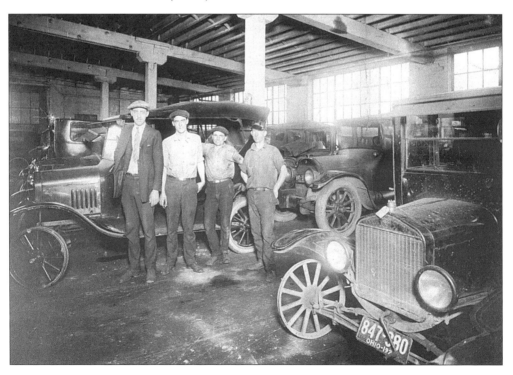

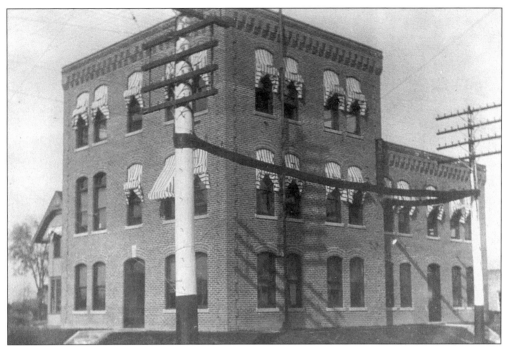

The American Telephone and Telegraph headquarters, constructed in 1902, was considered a model building with electric lights and employee washrooms. It provided employment for many Maumee women as switchboard operators until abandoned by AT&T. Its last tenant was the "Bargain Barn" before it was razed in the 1970s.

Eckert's Drugstore, where the first and only public telephone was located, was a gathering place for local businessmen, public officials, and residents. The building, owned by pharmacist L.A. "Bud" Eckert, was a local landmark for almost half a century before it was razed in 1937.

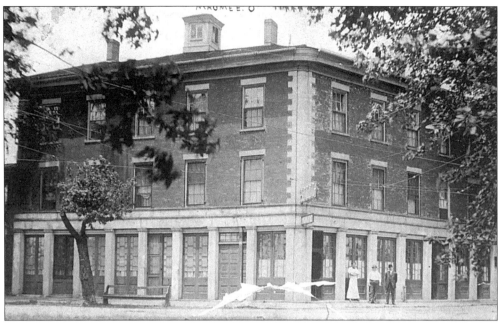

The Commercial Building, built in 1836 to house shops and offices, has served as an inn or restaurant since the 1840s when it was known as the Neely House. It has operated as the Eagle House, Bismark, the Schiely House, the Seurin Hotel, the Langly Inn, the Old Plantation, and is currently called the Linck Inn. It has remained relatively unchanged.

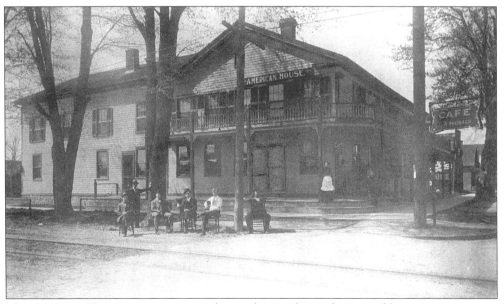

The American House was in its prime during the canal era when, in addition to serving as a hotel, it was the scene of many lavish balls. Originally located on Wolcott Street, it was moved to the corner of Conant and Dudley in 1842, where it remained until 1936, when it was destroyed to make way for a gasoline station.

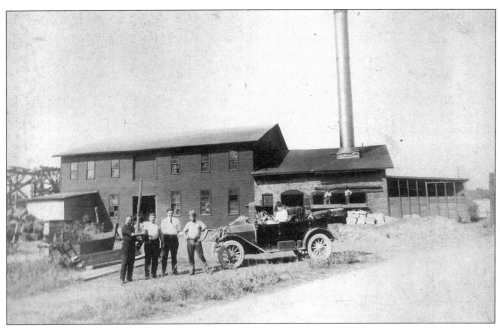

Daniel Carney purchased the former Mitchell Paper Mill on Ford Street near the flats and converted it to electric power. The company prospered during World War I by manufacturing corrugated paper. A later specialty was wrapping paper.

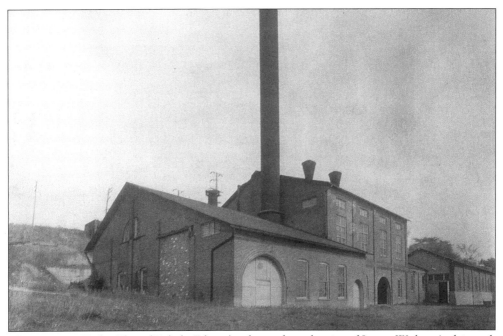

The Maumee Hydro Plant (Toledo Edison) is located on the site of James Wolcott's shipyard. In 1901, George Detwiler formed the first hydroelectric plant. The Maumee Valley Electric Co. took over in 1910 and served the Maumee Valley west to Defiance, merging with the Defiance Gas and Electric in 1917, ultimately becoming Toledo Edison. The electricity powered the Toledo, Maumee, Perrysburg, and Waterville electric cars.

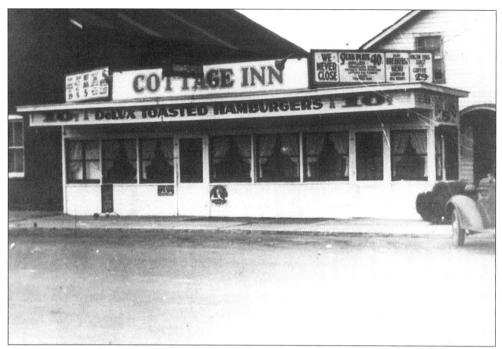

George Sheperd built the Cottage Inn in 1925. Norman and Al Spangler purchased and remodeled the building just before the outbreak of World War II. The diner boasted a modern lunch counter, maple booths with individual wall jukebox selectors, and 10¢ would buy a deluxe hamburger.

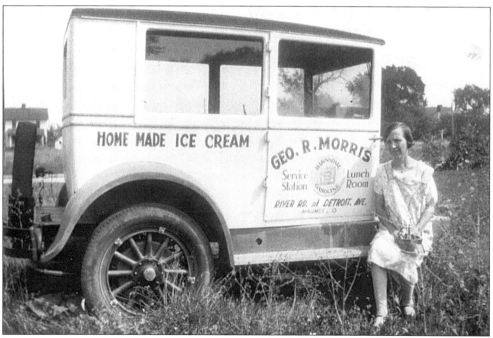

Mrs. George Morris rests on the running board of her husband's delivery truck in 1937. Morris operated a service station and lunch room on River Road at Detroit.

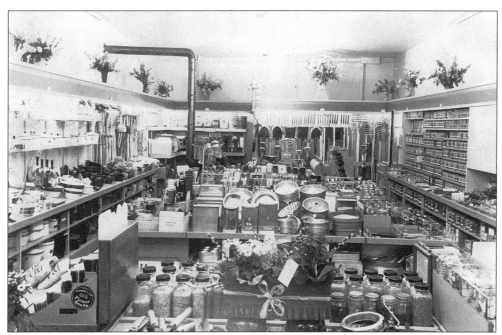

Before Anderson's, the place to go was Puhl's Hardware. The above photo, taken in 1940 at the grand opening of their new Conant Street store, shows the vast array of merchandise available. In addition, Puhl's provided many services such as sharpening tools and repairing appliances. George, the proprietor, and his brother Louis, the tool specialist, are posing below in front of their new tool section. The Puhls were in business for over 40 years.

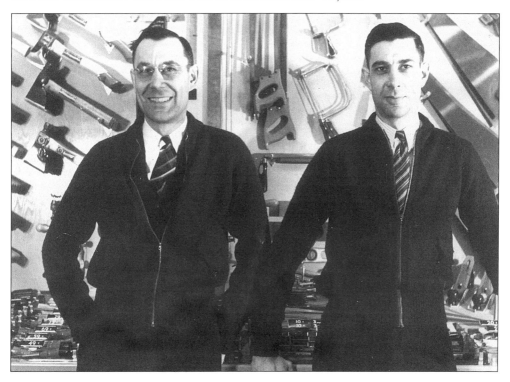

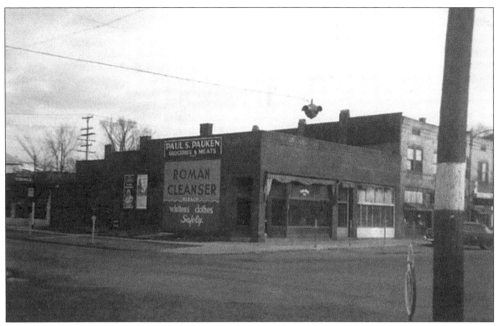

The Pauken family was in the grocery business for many years, beginning with Steven A. Pauken and followed by Paul S. Pauken, at 139 W. Wayne Street through the mid-1950s. Pauken's carried a "full line of Meats and Groceries" and promised prompt delivery.

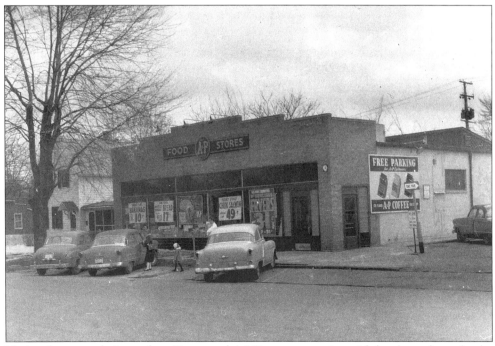

National grocery chains such as Kroger and A&P were competing with local merchants by the 1930s. This A&P store (*c.* 1950) on East Dudley enjoyed a large clientele, eventually moving to Golden Gate shopping mall in the 1970s.

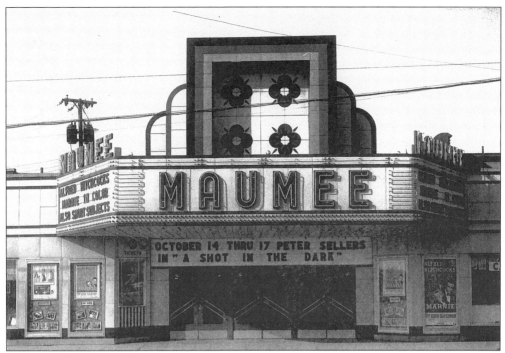

The Maumee Theater opened in September of 1946. The theater, with its sleek exterior and prominent marquee, boasted an outdoor ticket booth and fresh popped corn in the lobby. Generations of Maumee youngsters flocked to the Saturday matinees through the 1990s. It is listed on the National Register of Historic Places. It currently stands empty.

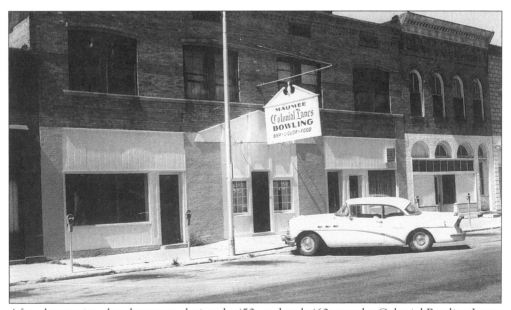

After the movies, the place to go during the '50s and early '60s was the Colonial Bowling Lanes around the corner on W. Wayne Street. Competition would come from the Timbers Bowling Alley as business moved north on Conant Street.

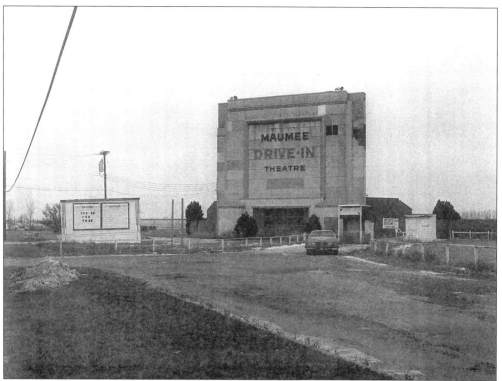

Further up Conant, on Reynolds Road, stood the Maumee Drive-In Theatre, a highly popular form of entertainment for families or young couples seeking privacy in their cars. It fell victim to the wide screen "cinema" and was demolished in the 1980s.

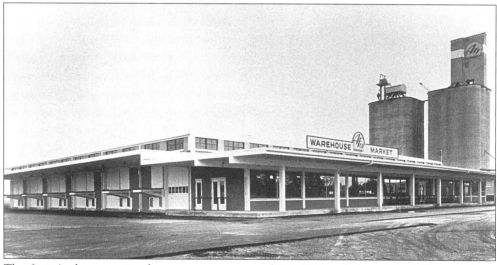

The first Anderson grain elevator was constructed in 1946, and the original General Store opened in 1952. It catered primarily to the farm trade, carrying agricultural implements and machinery, and work clothing. Toys and small appliances were eventually added and displayed on the metal shelves alongside the farm tools. The present General Store opened in 1972.

Three

COMMUNITY LEADERS, ORDINARY PEOPLE, AND INTERESTING VISITORS

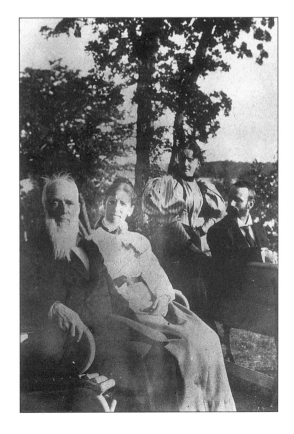

Early entrepreneur and "city father" Daniel Cook followed his parents to Maumee in 1834, shortly after his graduation from Harvard Law School, and began his law practice. He served in numerous civic capacities, including two terms as mayor. He is pictured here with members of his family. The family home remains on West Dudley.

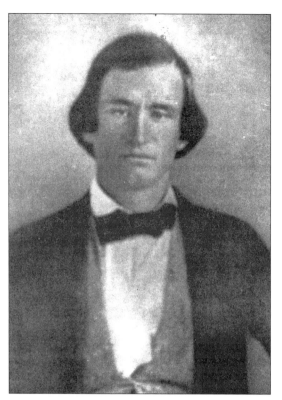

Almon Gibbs served as quartermaster and postmaster at Ft. Meigs during the War of 1812. He was one of the earliest settlers and entrepreneurs. His warehouse on East Harrison was the center of early political and mercantile activity. Gibbs married Chloe Spafford Gilbert, who inherited his real estate and developed her own addition to Maumee.

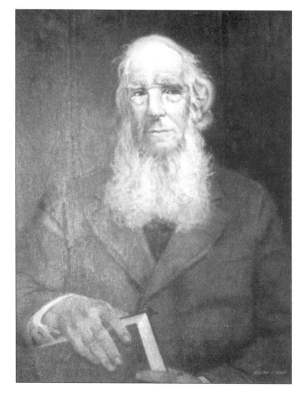

Horatio Conant gazes down from his portrait in the Presbyterian Church where he served as early Elder. Upon arrival in 1816, he entered into a retail partnership with Gibbs and later practiced medicine with Dr. Oscar White. He was the first clerk of Lucas County, and served as mayor of Maumee in 1848.

John E. Hunt arrived in 1816 and set up a trading post with Robert Forsyth, Maumee's first mayor. Active in politics, Hunt was elected mayor in 1839, and state legislator in 1835, 1839, and 1841. He later was appointed postmaster in Toledo.

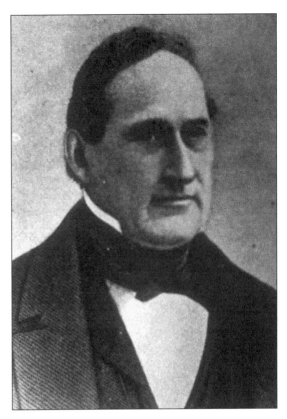

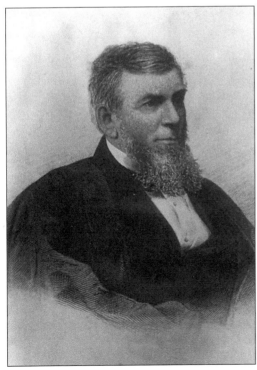

Morrison R. Waite, one of Maumee's most prominent early residents and a graduate of Yale Law School, served as mayor of Maumee in 1840. He was elected to the Ohio Legislature in 1849, and appointed to the Tribunal of Arbitration in 1871 to settle the Alabama claims. After presiding over the Ohio Constitutional Convention in 1874, he became Chief Justice of the U.S. Supreme Court in 1874.

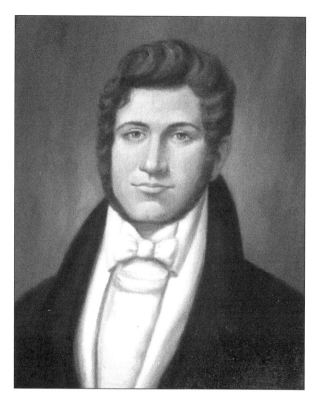

James Wolcott, a Connecticut native, emigrated to Maumee in 1827. He engaged in a number of enterprises including retail, wholesale, ship building, and real estate. He was first president of Maumee Village Council, was elected a Lucas County Common Pleas Judge, and was elected mayor in 1843. His wife was the daughter of William Wells and granddaughter of the Miami Indian Chief Little Turtle. Their home is now Wolcott House Museum.

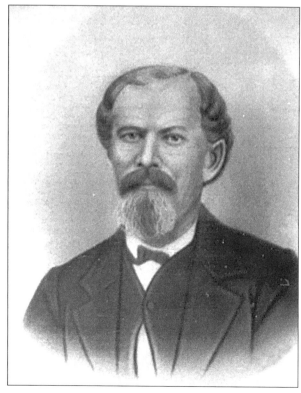

Smith Gilbert, another Connecticut emigrant, married Mary Ann Wolcott in 1848. He was elected mayor four times, the first in 1859, and steered Maumee through the difficult Civil War years.

Maumee exceeded the draft call throughout the Civil War. Twenty-three-year-old George R. Morris enlisted in 1961 in the Fourteenth Ohio Volunteer Infantry, the first group to leave Toledo under command of Toledoan General James Steedman. He was one of a number of Maumee boys who served in the Fourteenth.

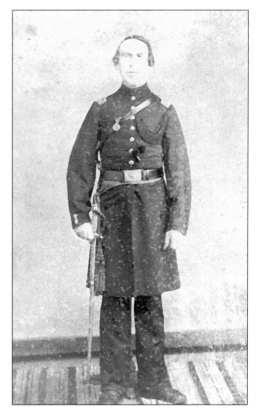

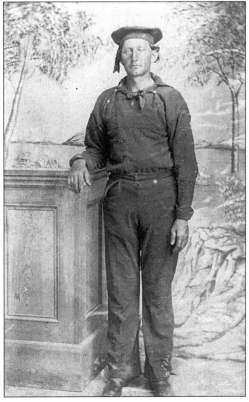

George Utter enlisted for a three-year stint in the Thirty-Second Ohio Cavalry. Upon completion, he enlisted in the United States Navy and served in that branch until the end of the war, when he returned to Maumee. He was a member of the Charles Mitchell Post of the GAR and a trustee of Riverside Cemetery. His family home still stands on W. Harrison Street.

Fanny and Ernie Utter, daughters of George Utter, in spite of war-time shortages are dressed alike in the prevailing fashion of the day, including the wide-brimmed straw hats. Pantaloons can be seen peeking out from under Ernie's full skirt.

Mary Emiline Smith, daughter of Horace T. Smith, prominent shipbuilder and village council member, was described as a "slender brunette with beautiful curls." George Morris's son, John, won her hand, and they raised their family on a farm on Scott Street, when "Miami" was still largely agricultural.

It was not uncommon for residents to hold membership in fraternal organizations such as Woodsmen of America. Daniel Flanigan (right) and his brother, carrying axes, appear to be dressed in the uniform of the Woodsmen or another similar organization. Flanigan owned a large farm on Monclova Road. The farmhouse is now located on the Wolcott Museum grounds.

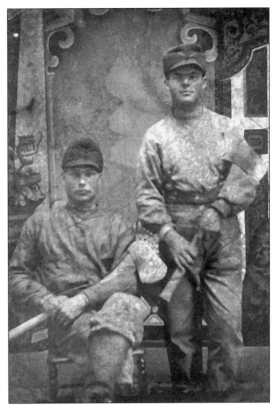

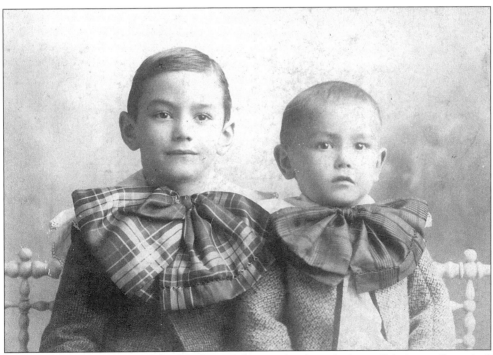

These two young boys are models of the latest fashion as they happily show off their new "bow ties."

Peter M. Puhl was one of the earliest photographers in Maumee, and probably photographed more area residents amid the potted palms and painted backdrops in his E. Harrison Street studio. He seemed particularly adept at capturing children. Pictured at left is Lawrence Miller, shortly before his death in 1893 at the age of four. It was important to photograph children at an early age as many did not survive until adulthood. Little Margaret Miller (below) seems to be enjoying her photo session, *c.* 1891.

In the 1890s, it was necessary to sit for photographs without moving for long periods of time. The Kane family appears to be experiencing "photo fatigue" during their session. Kane served on the Maumee Board of Education in the 1890s, and was a member of the Masonic Lodge.

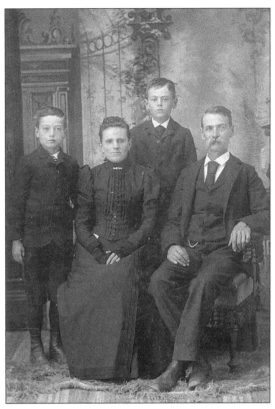

Lila Hynes was a teacher at the Ft. Miami School. This may be an early school photo. "P.M. Puhl" is inscribed on the back of the photo.

Christenings and confirmations were important landmarks in the lives of children. At left, Puhl photographed this young boy in his lace-trimmed christening gown in 1893. Thelma Zellars (below) shows off her new dress for her confirmation at St. Joseph's Church in the early 1900s.

The Schier sisters, Emma and Mae, and their grooms, Abe Soudriett and Joseph Sughars, were married in a double ceremony. Here, they pose in their wedding finery in Puhl's studio c. 1900. The brides' father was the proprietor of Schier's Grocery.

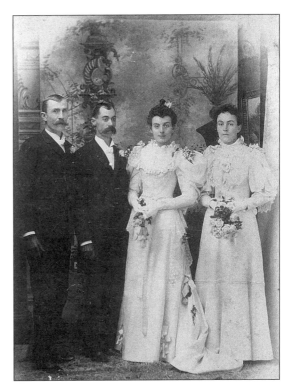

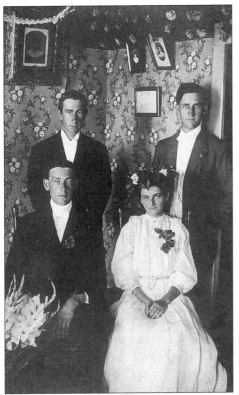

Some wedding parties preferred to be married and photographed at home. Pictured here, from left to right, are: Elias Cope (son of schoolteacher Peter Cope), bride Jenny Cooper, Arthur Cope, and the minister. This picture was later made into postcards to send to friends, a common practice after 1908.

The Botte family was typical of many Maumee families. John came to Maumee from Belgium in 1890. He and his brothers, Frank and Leon, were master glass blowers. His wife, Helen, was the great-granddaughter of Cordelia Geer, who came to Maumee in a covered wagon in the 1830s. They are pictured with their oldest daughter, Virginia, *c.* 1910.

Dean Myers, Mr. Devill, Ernest Simonet, Ademir Simonet, Mr. Brigade, Amile Chauste, and Victor Jacquet played with the Maumee Band in the early 1900s. They often played in outdoor concerts at the bandstand. John and Camille Botte, Florent and Louis Jacquet, and Hugo Seitz were also members of the band.

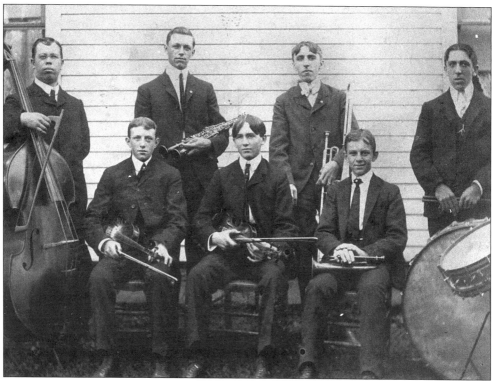

Musical instruments provided a great deal of entertainment in the 1890s and early 1900s. These unidentified youngsters are perhaps practicing to become members of the Maumee Community Band.

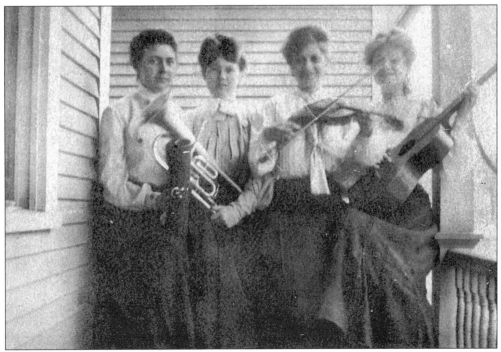

Although women were not allowed to become band members, Alta Richardson and her friends formed a musical group for their own enjoyment.

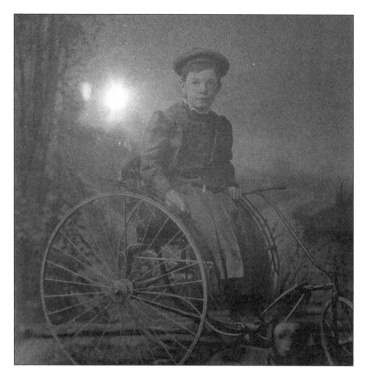

Cycling was a popular form of entertainment enjoyed by young and old. Rilla Hull is pictured on her tricycle in the early 1900s. With a three-wheeler, women and girls did not have to expose their limbs.

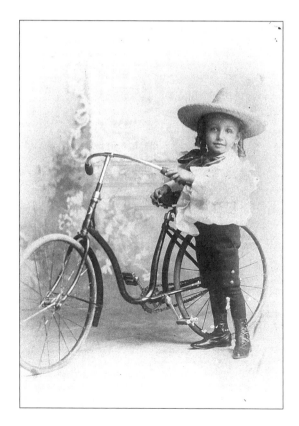

A two-wheeler could be purchased for $10–15 by 1900. George Morris (in curls) is showing off his cycle.

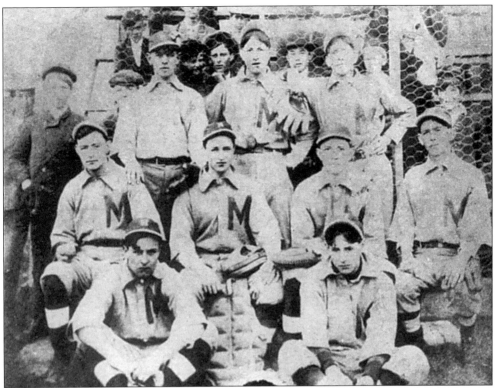

Baseball came into its own in the 1890s, and Maumee had several amateur teams. This 1913 team included, from left to right, as follows: (front row) Clarence Gibbs and Grafton Colburn; (second row) Arnold Navarre, unidentified, unidentified, and Edward Genslein; (back row) unidentified, Scoie Hopkins, Charles Henfling, and Peter Brell.

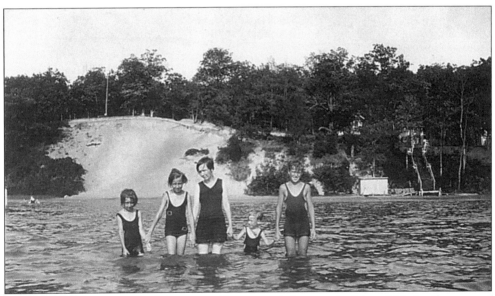

During hot summer months, Maumee residents traveled to nearby lakes. This family group of three girls and two boys is enjoying the waters.

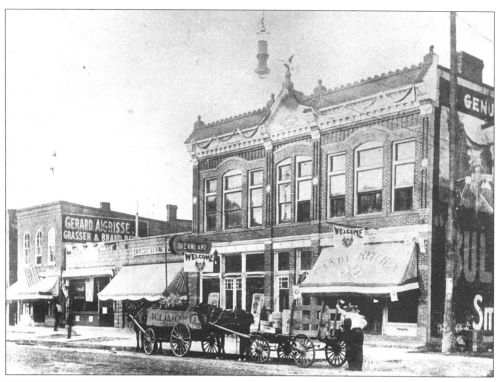

In the early 1900s, silent movies came to the Dreamland Theater in the Henfling Building. Countless numbers of Maumee youngsters and adults spent afternoons watching the movies before migrating next door to the Candy Kitchen for refreshments (above). Gladys Bachelder Stanley began her career singing and dubbing voices at the Dreamland. She and her husband, George, later toured the vaudeville circuit as the "Georgia Crackers," a song and dance team. They retired to Maumee in 1947. Gladys is pictured at left.

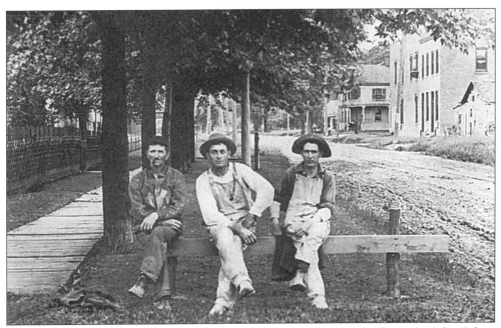

Sometimes just sitting was the best way to relax on a warm summer afternoon. John Schier (middle) and James Ryan (right) take a break with an unidentified friend on W. Dudley Street alongside the wooden sidewalk. The American House is visible on the right.

THE HISTORY
OF MAUMEE
1748 - 1926

COMPILED AND PUBLISHED
BY
JOHN A. SMITH
MAUMEE, OHIO

HENRY M. SCHMIT, Printer
TOLEDO, OHIO

The peaceful tranquility of the village was shattered when the United States entered the World War in 1917. John Smith was elected mayor and served throughout the war. It was his third term as mayor. He was elected again in 1919, and served two more terms during the Depression. In addition to his retail activities and civic duties, he found time to gather records, clippings, and anecdotes of the village history and compiled them in his History of Maumee, published in 1926.

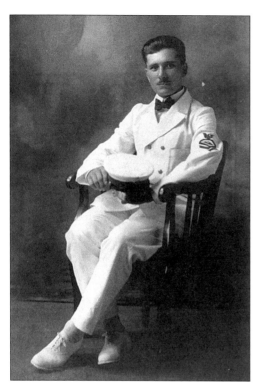

Sylvester Dennis, looking dapper in his Navy whites, was one of the first Navy pilots to train at Key West, Florida, for World War I. He returned to Maumee after the war, where he served as Commissioner of Streets for 23 years, retiring in 1958. He was awarded the "Book of Golden Deeds," the Exchange Club's highest honor, in 1974.

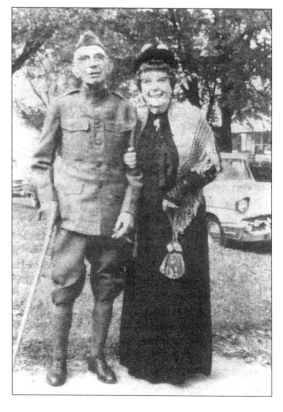

In 1960, Charles "Bud" Schnapp, in his World War I Army uniform, poses with his wife, Eva Malfair Schnapp, for a picture. The Schnapps were the first local couple to wed under war-time circumstances. Eva, the daughter of Belgian immigrants, became very active in the American Red Cross and the Women's Relief Corps. For 38 years, she gave a speech and read off the names of all the fallen veterans at the annual Memorial Day celebration.

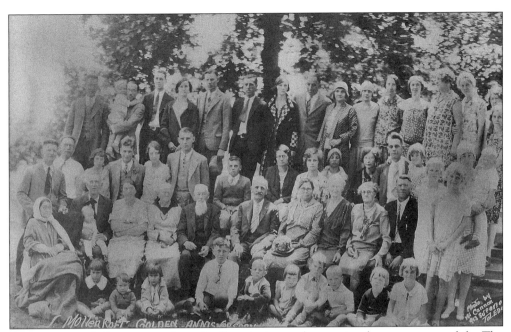

Reunions provided a means to keep family units in touch as society became more mobile. The first Mollenkopf came to Maumee from Germany in the 1830s, and family members were involved in various retail activities. John A., a baker, was a charter member of I.O.O.F. The Mollenkopf family gathered in 1926 to celebrate the golden anniversary of John (center) and his wife.

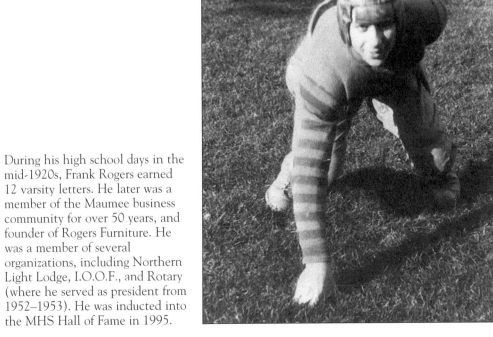

During his high school days in the mid-1920s, Frank Rogers earned 12 varsity letters. He later was a member of the Maumee business community for over 50 years, and founder of Rogers Furniture. He was a member of several organizations, including Northern Light Lodge, I.O.O.F., and Rotary (where he served as president from 1952–1953). He was inducted into the MHS Hall of Fame in 1995.

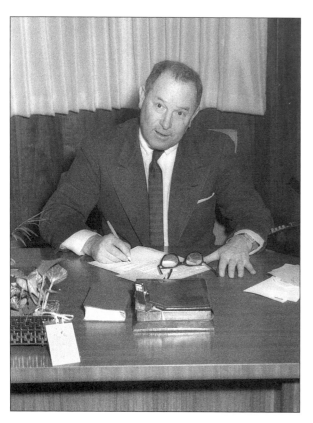

As Maumeeans began to feel the effects of the Great Depression, residents pulled together. Malcolm Ward, rector of St. Paul's Episcopal Church, assumed a leadership role in the welfare effort by helping to organize a community fund for the destitute. The church operated a food and clothing distribution center and opened its doors for "use by the unemployed," and as a meeting place for groups to pack Christmas bread baskets.

Housewives learned to be resourceful. Bernice Brell skillfully handmade and smocked this blue dimity dress (just like the ones popularized by child actress, Shirley Temple) for her daughter, Rachel, photographed on W. Harrison Street in 1932.

During the Depression years, Earl Martin founded the Home Federal Savings and Loan, a locally owned and operated financial institution which provided assistance to many Maumee businessmen and homeowners over the years. The early directors included E.H. Perrin, Dr. W.M. Gills, Chas. Wittich, C.C. Dussel, Patrick Wise, A.G. Maxwell, and C.A. Parish. Martin served as secretary.

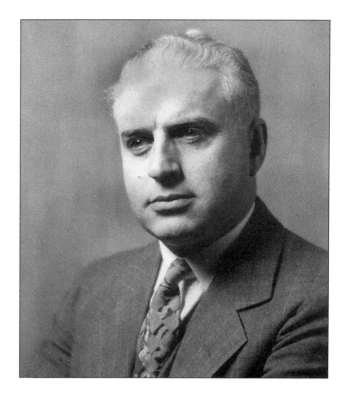

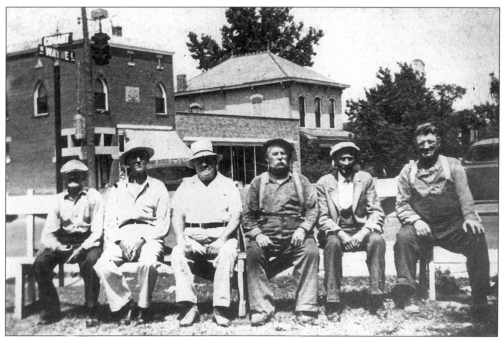

After the demolition of the Eckert's Drugstore in 1937, a small park evolved in the empty lot where old-timers, referred to as the "Roosters Club," liked to gather. Pictured, from left to right, are: Charles McIntyre, Joe Smith, Frank Lautzenheizer, John Steffes, Leon Botte, and Jake Hahn, *c.* 1940.

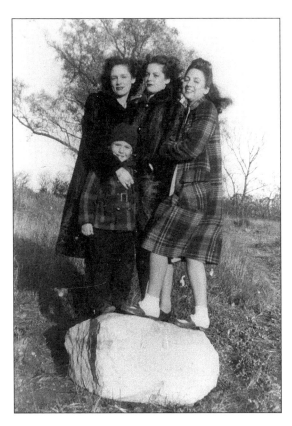

Joyce Lajinnes, Loyala Lajinnes, and Evelyn Morris, in fur coats and bobby sox, and young Ronnie Morris enjoy a wintry outing along the Maumee River in 1942, forgetting for a moment that the United States had been plunged into war on the previous December 7.

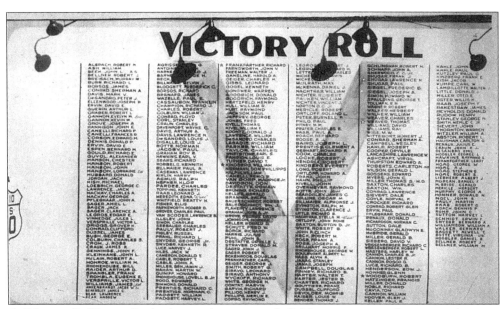

A "Victory Roll" proudly displaying the names of all Maumee men and women who were serving in the armed forces was unveiled on the wall of Smith's Drugstore on Memorial Day in 1942. The roster would continue to be added to over the next three years.

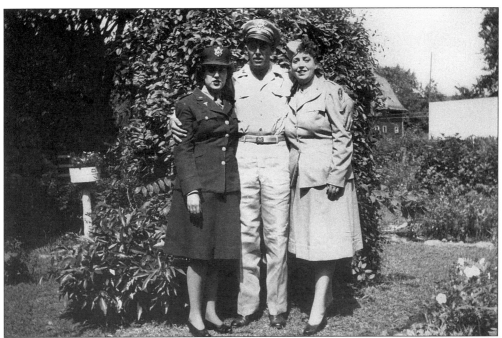

Nearly every family had at least one member, sometimes more, in the U.S. Armed Forces. John and Helen Botte proudly displayed four blue stars in their window for their children. Pictured above, from left to right, are: Lt. Helen Botte, Army Nurses Corps; Captain Jack Botte, USN; and Sgt. Virginia Botte, WAC Intelligence serving under General Marshall in WDC. Below is Norman (Bud) Botte, Chief Petty Officer, USN.

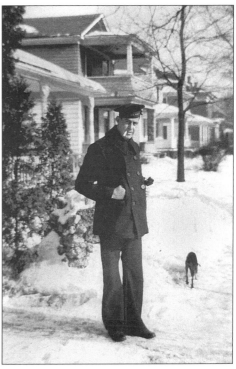

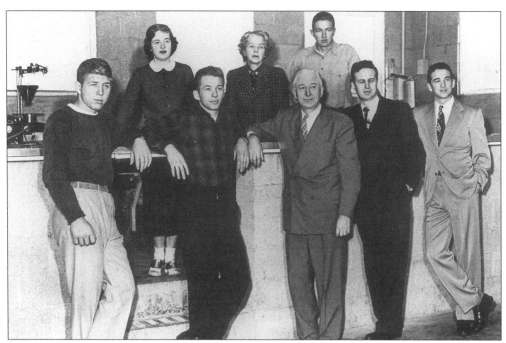

Harold and Margaret Anderson established The Andersons as a family partnership in 1947. Pictured in 1950, from left to right, are: Dick, Carol, Bob, Margaret, Harold, Tom, John, and Don. The first Anderson Truck Terminal was built by using college students and the Anderson sons to construct the 500,000-bushel grain elevator. By 1950, the facility had doubled in size. The Andersons continues to diversify and grow, both in physical size and organizational structure.

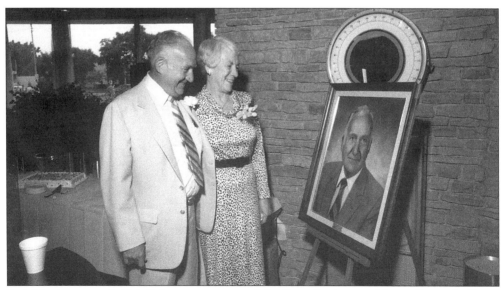

Earl Martin succeeded his father as secretary of the State Savings and Loan (formerly Home Federal). Earl and his wife, Isabel, examine Earl's portrait at his retirement party in 1983. Both were active in the community. Isabel was an active volunteer, and served as a consultant for United Way from 1960–1985. She was the first woman to be appointed to a corporation board in northwest Ohio.

Rilla Hull, the great, great-great-granddaughter of Miami Indian Chief Little Turtle, is holding a family heirloom and explaining its history to an unidentified observer.

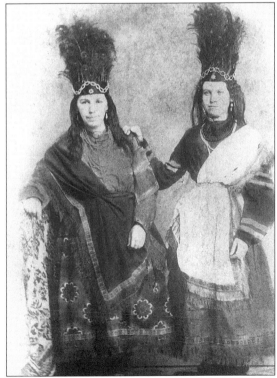

Rilla's grandmother, Mary Ann Wolcott Gilbert (left), and her mother, Frederick Gilbert Hull (right), dress for the photographer in their version of an Indian costume. Both women passed along pride in their Miami heritage, and in their family homestead, the Wolcott House, to their children.

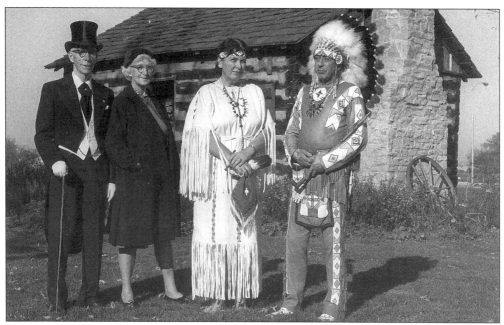

Mr. and Mrs. Wade Baldwin are dressed in Native American costume for a special occasion at the Wolcott House. Wade was descended from Chief Little Turtle through Mary Wells Wolcott, and was instrumental in keeping the Miami culture alive. The Baldwins organized the Miami Indian Dancers in 1953, and became well-known performers at tribal gatherings throughout the Midwest. To the left are Alta Richardson and S.E. Klewer, also dressed for the occasion.

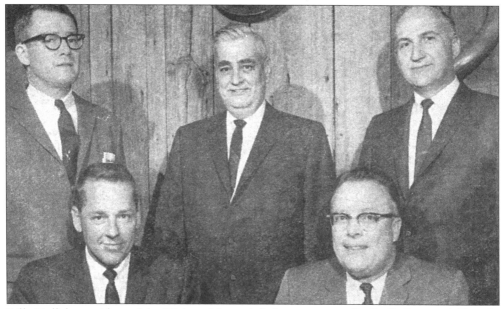

Rilla Hull, last resident of the Wolcott House, left the property to St. Paul's Episcopal Church, which leased the riverfront to the Indian Hills Boat Club in the 1960s. Early officers were, from left to right, as follows: (front) Wilbur Donaldson, Vice Commodore; and Herbert Savage, Commodore; (rear) Donald Buckout Jr., Rear Commodore; Wayne Lilly, Harbormaster; and Earl Martin, Secretary-Treasurer.

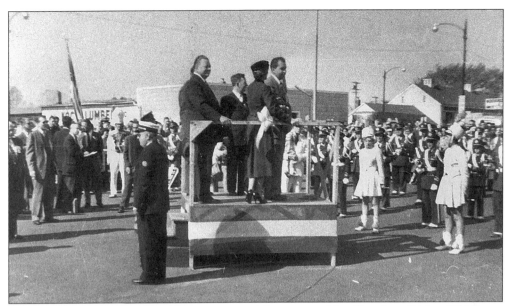

Among the interesting political figures to visit Maumee was Vice President Richard F. Nixon, who would later be elected president. Nixon and his wife, Pat, attracted a large crowd when they came through Maumee on a 1956 campaign tour. The VP was given a rousing introduction by Judge Harvey Straub (pictured on the platform), and the Maumee High School Band provided patriotic accompaniment from their front-row position.

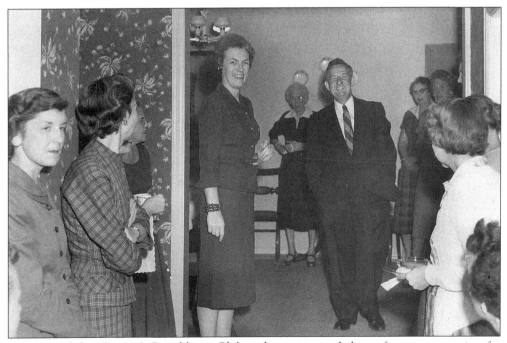

Members of the Women's Republican Club and guests attended an afternoon reception for Ohio Governor William O'Neill at the home of Mrs. Earl Martin in 1958. Pictured to the left of the governor is Mrs. Martin, and in the background are her mother, Mrs. Pye, Mrs. S.E. Klewer, and Mrs. Nat France. The rest of the guests are unidentified.

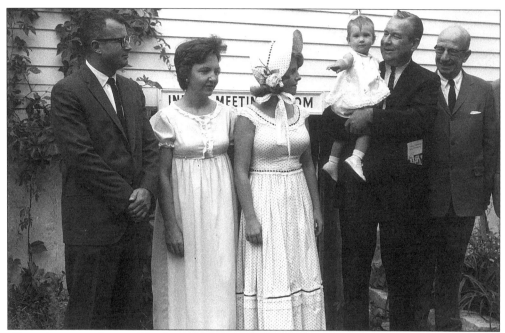

Ohio Governor James Rhodes made several visits to Maumee during his long tenure (1963–1971 and 1975–1983). During the 1960s, he paid a special visit to the Wolcott House. He is pictured with the following from left to right: Cliff Dussel, mayor of Maumee (1961–1967); Wolcott Docents Ruth Ann Conway and Dru (Cassidy) Hazard; and historical society president Ralph Day. Rhodes's young granddaughter appears to be enjoying the attention.

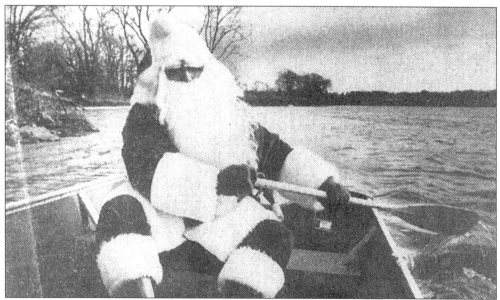

By far, the most eagerly anticipated visitor to Maumee was Santa Claus. For over 25 years, Wayne Pfleghaar was Santa to hundreds of Maumee children. Wayne liked to vary his entrance, even arriving by helicopter. On this occasion in 1974, Santa arrived by boat in time to make his appearance at the annual Community Christmas Party.

Four

COMMUNITY ORGANIZATIONS

PUBLIC AND PRIVATE

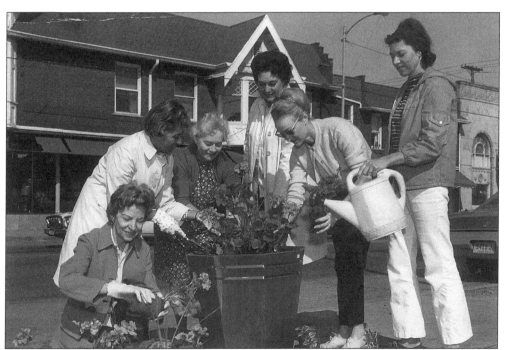

Civic beautification was one of the goals of the Federation of Garden Clubs, formed in 1955. During the 1960s, they became involved in the effort to improve Maumee's uptown area with flowering plants and trees. Pictured planting the first boxes are representatives from each club. They are, from left to right: Mrs. Nat France, Mrs. Harold Carr, Mrs. Keith Knight, Mrs. Don Musselman, Mrs. Nick Wagener, and Mrs. Peter Wendler.

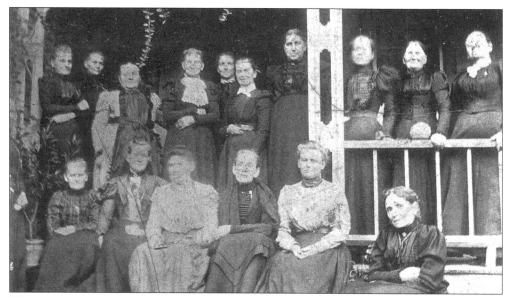

When a "woman's place was in the home," women had few opportunities for community involvement. The Woman's Relief Corps, organized as the Soldier's Relief Society during the Civil War, was one of the earliest woman's groups. It remained active until the mid-1900s. From left to right are the members of this organization, as follows: (at far left) Fredericka Hull; (seated) Mrs. Crain, Mrs. Van Renslaar, Mrs. Gunn, Mrs. Henish, and Mrs. Lucas; (standing) Mrs. Gilbert, unidentified, Mrs. Rodd, Mrs. Brown, Mrs. Dean, Mrs. Van Fleet, unidentified, Mrs. Myers, Mrs. Clark, and Mrs. Mollenkopf.

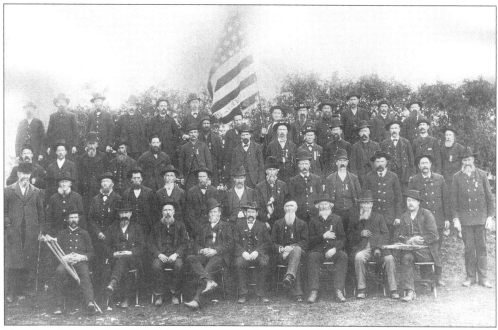

The Grand Army of the Republic was open to all veterans of the Civil War and was dedicated to assisting former soldiers and their families. They also insured that the graves of veterans were appropriately marked and decorated each Memorial Day.

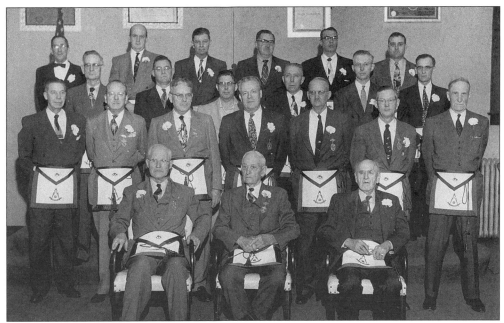

In 1954, past Masters of the Masonic Lodge Northern Light No. 40, the earliest fraternal society in Maumee, gathered for a photograph. Seated chronologically, in order of office (and from left to right) are as follows: (first row) John Lloyd (1904), William Smith, and Jesse Brant; (second row) Harry Smith, Howard Rhinehalt, Norton Woods, Carl Allmaier, Charles McPeek, Dr. S. Stout, and Clark Allman; (third row) Harry Zimmer, Melvin Cass, Mel Prahl, Francis Thompson, William Beck, and Don Noel; (fourth row) Fred Richards, John Boyd, Carl Strausburger, Waldo Ducatta, Harold Johnson, and Carleton Stewart.

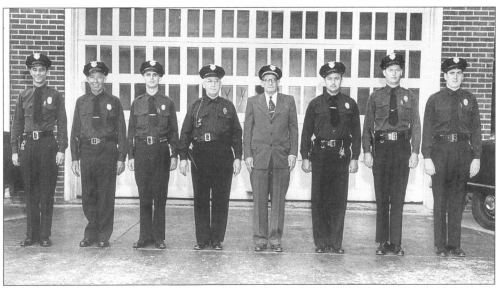

Clarence Shepherd was the first full-time police chief in 1940. He served as a police officer for 38 years, the earliest as a lone constable. He is shown here in 1940 (at center) with his seven officers. They are, from left to right: Mr. Rogers, Mr. Overmeyer, Mr. Taylor, Mr. Bowers, Mr. Simmons, Mr. Bagget, and Mr. Naumon.

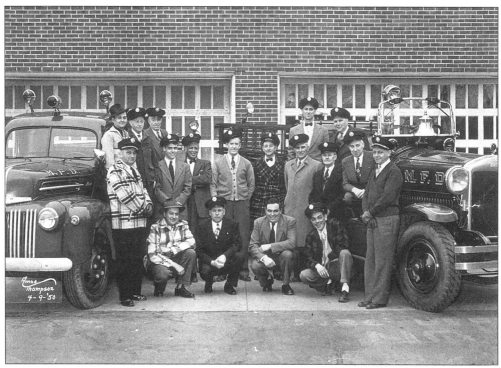

Maumee's Fire Department began as a volunteer organization in 1843. It was still volunteer in 1950 when these firemen lined up for a photo with the 1928 Ahrens Fox. Pictured, from left to right, are: Ralph Burdo (Fire Chief for 32 years), Mr. Henfling, Walter and Alfred Lambillotte, Paul and Carl Pauken, Carl Gary, John Kivell, Clem Caseman, Alfred Caseman, Sylvester, Dennis, Phil, and Wayne Pfleghaar, Fred and Dick Charter, Lynn Sheperd, Harold Curtis, and Malcolm Ward (Chaplain).

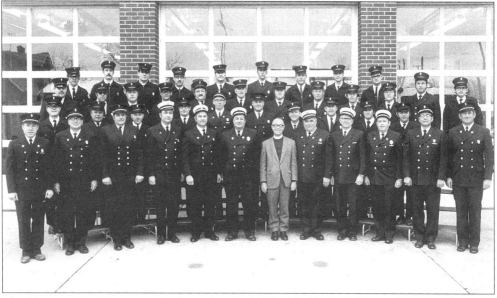

The Maumee Fire Department is shown here in 1972 with Chaplain Howard Graham (center).

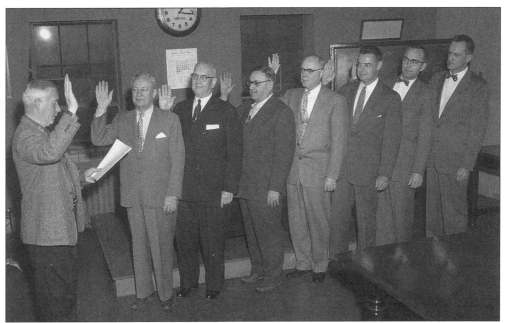

For many years, the offices of mayor and councilman were strictly voluntary and considered to be a civic duty. That changed when Maumee became a city, and the municipal structure expanded. In 1956, S.E. Klewer administered the oath of office to Earl Boxell, Calvin Love (the former mayor), Frank Hackett, Robert Meffely, Joe Herbert, George Burntt, and an unidentified man in the old city hall.

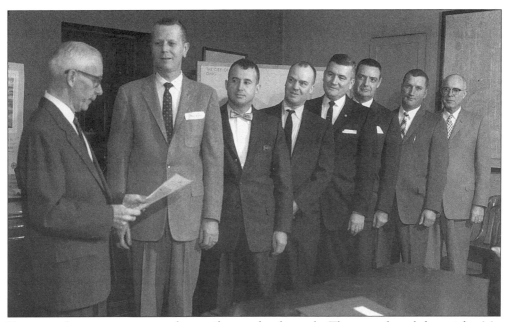

Four years later, a new group of councilmen take the oath. They are, from left to right: Mr. Klewer, Robert Nooney, Cliff Dussel (mayor from 1961–1967), Robert DeBrock, Art Buffington (mayor from 1967–1979), Joe Herbert (mayor at the time the photo was taken), Nick Wagener, and Robert Meffley.

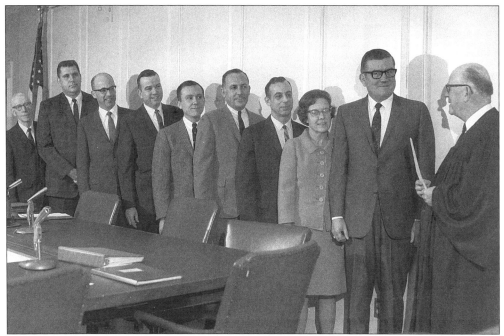

In 1968, Dorothy Herbert became the first woman to serve on city council. Judge McKenna administered the oath in the new council chambers. She is joined by Mayor Art Buffington at the far right. Council members Jim Dussel, Jim Pauken, Don Knepper, George Smith, Al Brogan, and Paul Muenzer (from right to left) were also present. S.E. Klewer looks on.

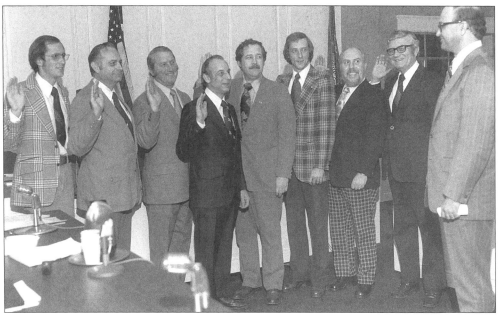

In 1972, college student Tom Dibling (left), at 19, was the youngest member to serve on the council. Other members, from left to right, are: Joe Pauken, Nick Wagener, Jim Dussel (mayor from 1980–1985), John Stout, Richard Kreiger (City Administrator/Safety Director from 1980–2000), Dick Hufffman, Mayor Art Buffington, and Judge Wendell Allen.

Five

CELEBRATIONS, PARADES, AND SPECIAL EVENTS

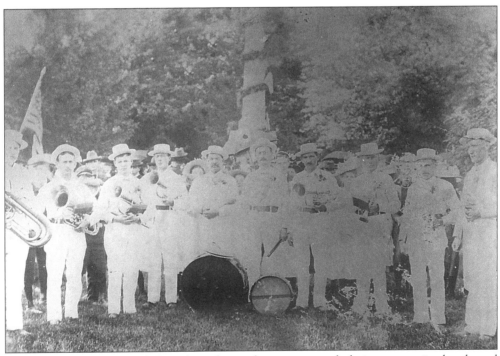

Residents of Maumee and Perrysburg have always supported their community bands and parades, which often traveled back and forth across the river. This group is assembled at the Soldier's Memorial for a Decoration Day Parade and concert.

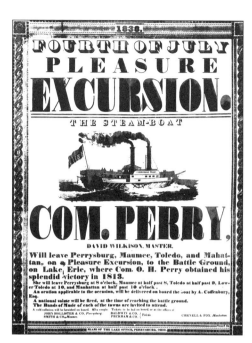

1838.
FOURTH OF JULY
PLEASURE
EXCURSION.

THE STEAM-BOAT

COM. PERRY,

DAVID WILKISON, MASTER.

**Will leave Perrysburg, Maumee, Toledo, and Mahat-
tan, on a Pleasure Excursion, to the Battle Ground,
on Lake, Erie, where Com. O. H. Perry obtained his
splendid victory in 1813.**
She will leave Perrysburg at 8 o'clock, Maumee at half past 8, Toledo at half past 9, Low-
er Toledo at 10, and Manhattan at half past 10 o'clock .
An oration applicable to the occasion, will be delivered on board the boat by A. Coffinbury,
Esq.
A national salute will be fired, at the time of reaching the battle ground.
The Bands of Music of each of the towns are invited to attend.
A cold collation will be furnished on board. $3 a couple. Tickets to be had on board, or at the offices of
JOHN HOLLISTER & CO., Perrysburg. BALDWIN & CO., } Toledo
SMITH & CO., Maumee. PECKHAM & CO. } CORNELL & FOX. Manhattan.

MIAMI OF THE LAKE OFFICE, PERRYSBURG, OHIO.

Fourth of July excursions were popular throughout the steamboat era. The community bands of each town participated and residents returned home after a day-long celebration, tired but happy.

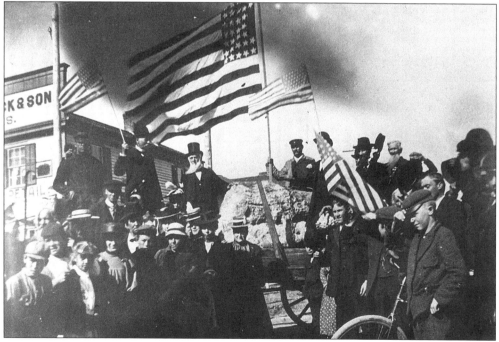

In 1903, Maumee residents were outraged to discover that the revered Turkey Foot Rock had been stolen by Toledoans! They launched a search party which quickly located the relic, and townspeople turned out in force to welcome its return. Standing triumphantly next to the rock is Daniel Cook, to the left. Tip (J.M.) Wolcott waves a flag. Peck Griswald, wearing the cap, holds another flag. Others pictured are: Phil Hartman, Ad Coffin, Mr. Stanley and Lucille Bachelder, Gus Johnson, Leota Harrington, Ede Spaulding, Lib and Frank Soudriett, William Dennis, and Carl Rodd.

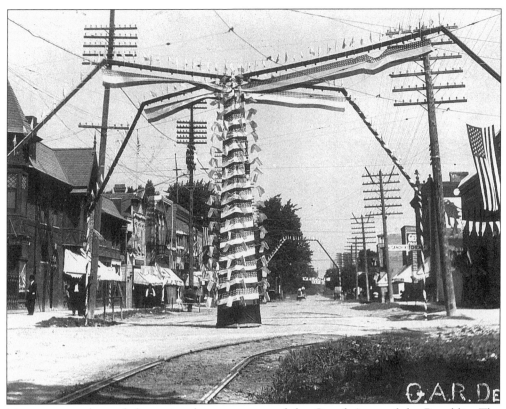

Maumeeans welcomed the national encampment of the Grand Army of the Republic. The entire town is festooned with flags and banners (top). A highlight of the celebration was a parade led by the Maumee Community Band. The veterans, cheered on by spectators, march behind as young boys in knickers and caps run alongside the band (below).

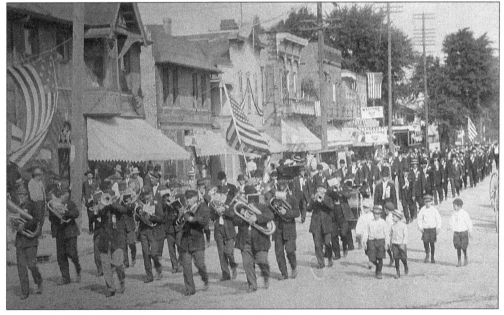

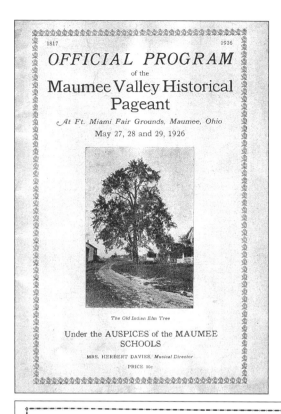

The Maumee Valley Historical Society organized their first historical pageant in 1926. The cast roster included literally hundreds of Maumee residents, young and old, and attempted to portray the history of the valley in three consecutive performances at the Ft. Miami Fairgrounds. The highlight was the announcement of "Miss Maumee," Frances Gulick.

Condensed Program of Daily Events

THURSDAY

8:15 P. M. The Centennial officially opens with the Commencement exercises of the Maumee Public Schools to be held in the high school auditorium. A Century of Progress in Education is the theme of the program and a locally-made moving picture will portray the advances in education in this community since the days of Dr. Horatio Conant, pioneer educator of the Maumee valley.

8:30 P. M. Fun on the Midway for all. Ace Mason, Master Magician, will give a free entertainment at the speakers' stand in front of the Edison building with amazing feats of magic and legerdemain.

FRIDAY — HOME-COMING DAY

3:30 P. M. The Hon. Arthur H. Day, Justice of the Ohio Supreme Court, will deliver the Home-Coming address from the speakers' platform in front of the Edison building. Judge Day is one of Ohio's most noted jurists and is a candidate for the United States Senate in the August elections on the Republican ticket.

8:00 P. M. The Michigan Mountaineers, presented by the Ford Dealers of America, will provide an hour of fun and amusement for all at the speakers' stand.

10:00 P. M. Ace Mason, this time with Charley, will be on hand with a lively program of skill and fun.

SATURDAY

3:30 P. M. Grand Parade and Band Festival. Seven high school bands, nine American Legion musical organizations, the 90-piece J. W. Greene band, six drill teams from the American Legion Auxiliary and many historical floats will participate. Follow the parade to the Athletic Field, where exhibitions of fancy drill and a band festival will be held. Admission is free. Grandstand seats are 10c.

10:00 P. M. Ace Mason again. This time it is with some of the escape feats made famous by the great Houdini.

10:00 P. M. Erica Ransome's Famous Six with a program of acrobatic and specialty dances at the speakers' platform.

10:30 P. M. Grand drawing of prizes. All prizes to be given at the Centennial will be drawn and awarded at this time. Tickets may be purchased from members of the Committee and at most of the stores in Maumee.

Ray Badger, famous Rube Comedian, will be present throughout the celebration. Be sure to see him.

SUNDAY

Home-Coming Day in the Churches. Your pastor has a message for you which will climax the entire celebration. Please consult the Church page of the program for hours of services in Maumee Churches.

A different type of celebration took place in 1938, when Maumee celebrated the one hundredth anniversary of its incorporation with three days of fun-filled activity.

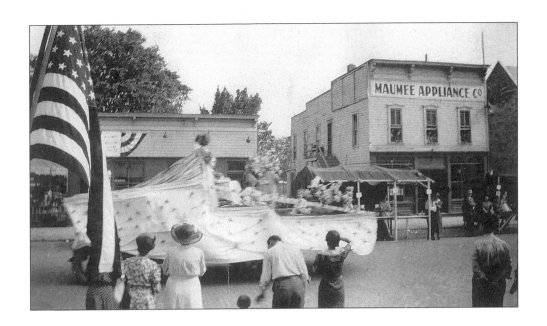

A parade is not complete without decorated floats, and local civic organizations competed for top honors in creativity. The float at top is approaching the corner of Wayne and Conant Streets. The Maumee Appliance Co. Building that appears in the photo was razed in the 1960s. A "modern" Kroger store (Sterlings) replaced the smaller building. The Ferris wheel (bottom) and other rides are located in the vacant corner lot.

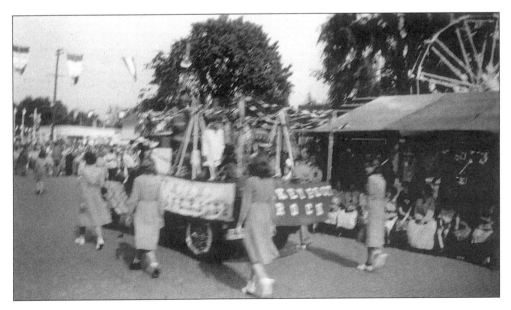

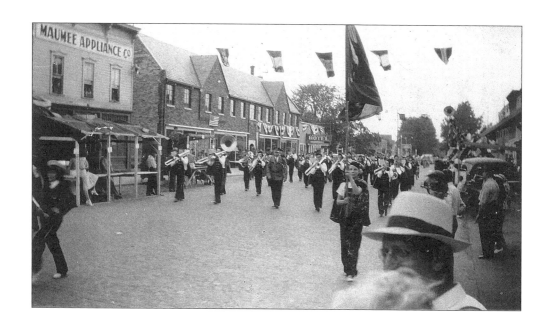

Residents line Wayne Street to watch the five area high school bands pass by. Puhl's Comfort Station (hotel), and the bus stop can be seen at the far end of the block beyond the new Clark Building.

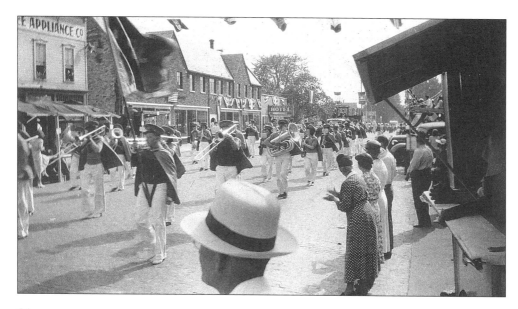

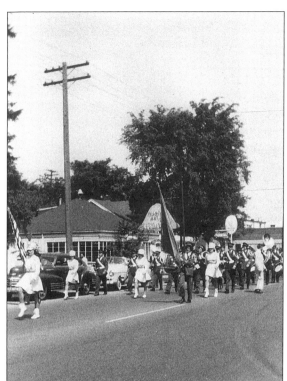

The Maumee High School Band leads the parade down Conant Street past the Dinner Bell Restaurant during the traditional Memorial Day Parade in 1955. A woman's auxiliary, probably the Women's Relief Corps, continues the march to the ceremony at Union School. One woman carries a wreath to place on the monument (below).

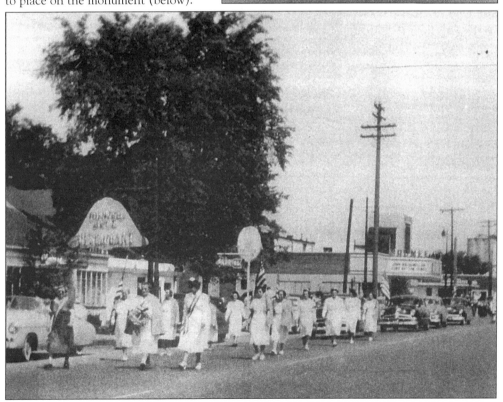

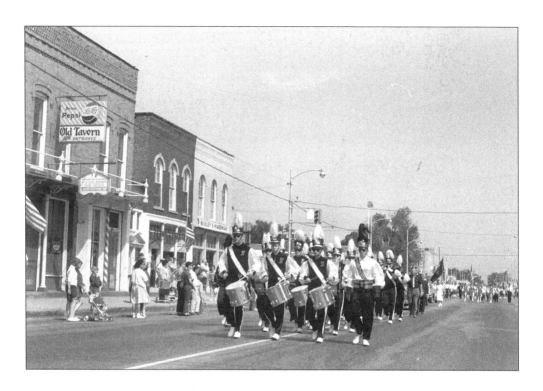

A decade later, the Maumee High School Band leads the Memorial Day Parade along the same route past several bars, a barbershop, Diblings Floor Covering, and Bigley's Hardware (top). A Brownie Troop leads the scout delegation in the lower photo. Puhl's Hardware is on the far left, and Calipetros Bar occupies the former Strand Theater Building.

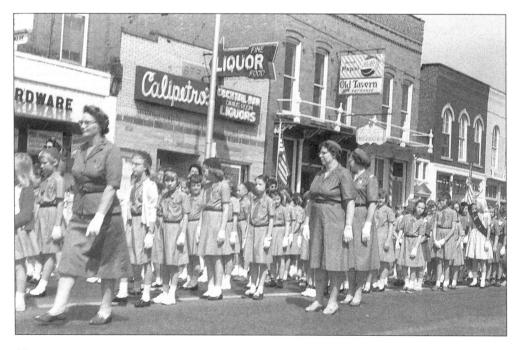

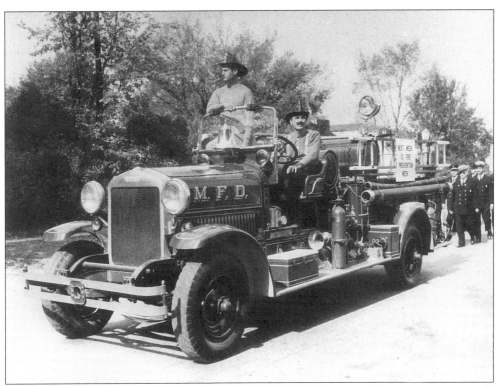

Maumee celebrated 125 years in 1963 with parades, contests, and a community party. Volunteer firemen Dick Kramer and David Dennis, driving the old Ahrens Fox, led a contingent of Maumee firemen in the parade (top). Sally Klewer, dressed in period costume, and his wife, Violet, paused outside the Dinner Bell Restaurant with Earl Martin, who is cultivating a beard for the beard-growing contest (below).

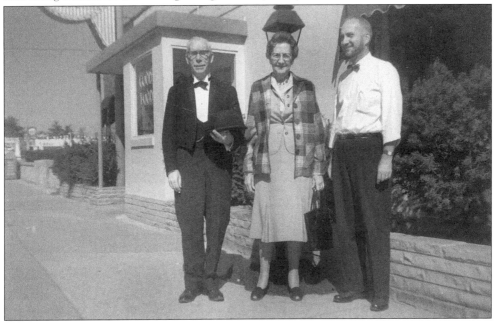

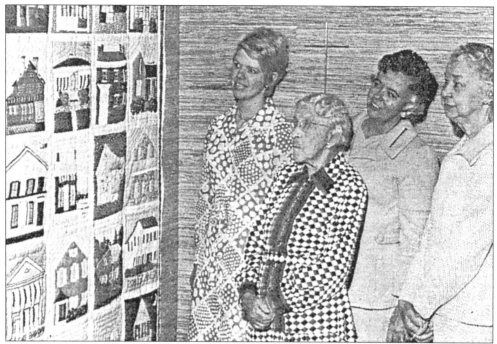

Residents celebrated the nation's Bicentennial in 1976 with the usual parades and parties, but one group of women decided to leave a more lasting memorial. Admiring the handmade quilt composed of blocks of historic Maumee homes are, from left to right: Marcia McCready, Margaret Puhl, Daphne Kohler, and Florence Puhl.

A week of special activities marked Maumee's two hundredth anniversary celebration, and culminated in a community parade with bands, floats, clowns, and horse-drawn carriages.

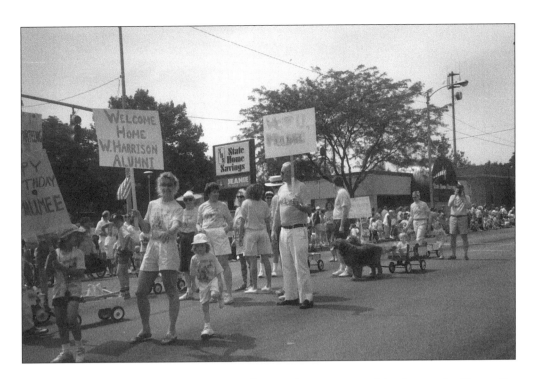

This group of Maumee residents was one of many that participated in the parade. Nancy Fry (top) carries the "Welcome Home" sign followed by Mollie Ehni, Karen Merrels, and Andy Merrels carrying a "We love Maumee" sign. Following Nancy Day (bottom), Ben Marsh pauses to help a small marcher readjust her sign.

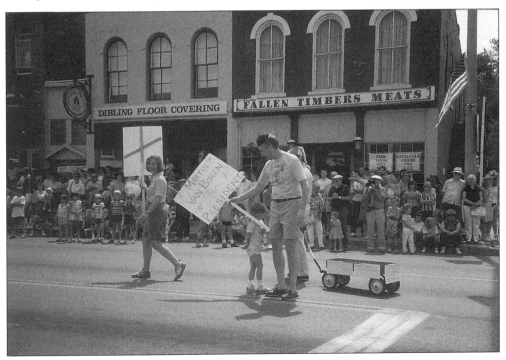

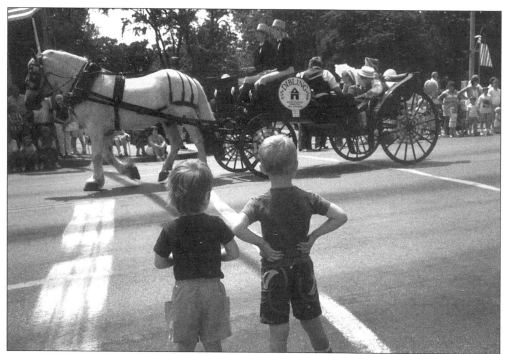

Maggie Wendler and Steven Schneider have a front row spot to watch Jim and Mary Dibling and their grandchildren Bridget, Brian, and Katie pass by in a horse-drawn carriage.

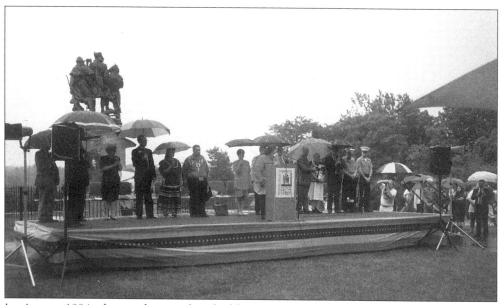

In August 1994, during the two hundredth anniversary of the Battle of Fallen Timbers, hundreds of residents were undeterred by pouring rain to attend the commemoration of the battle and the dedication of a monument to the Native Americans. Many area dignitaries, including members of the American Intertribal Association, General Walter Churchill, descendants of Chief Little Turtle, Maumee Valley Historical Society representatives, and Robert Smith, president of the Ohio Historical Society, braved the weather to take part.

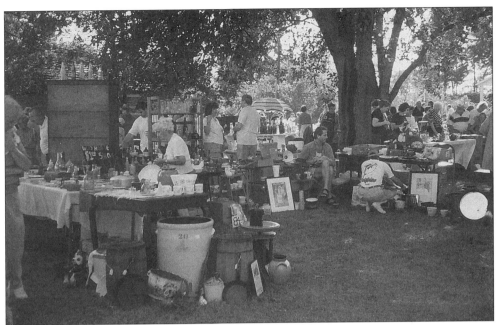

The Community Lawn Sale, sponsored by the Lucas County/Maumee Valley Historical Society, has been an annual event since 1960. Approximately 70 dealers (amateur and professional) set up booths on the lawn of the Wolcott Complex to sell their wares to the hundreds of onlookers. It is a day of fun with food and entertainment for all.

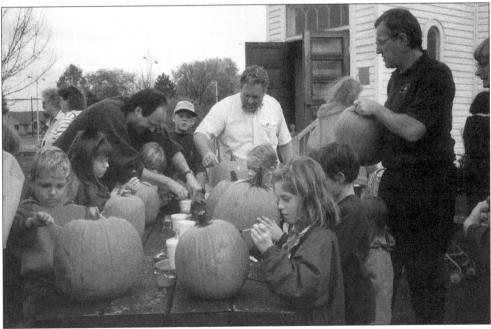

An annual community event also sponsored by the LC/MVHS is the Halloween/Harvest Days celebration begun over a decade ago. Randall Kent, Kent Gardam, and an unidentified father (top) are pictured helping their children decorate pumpkins. Live animals, music, food, craft demonstrations, and a Halloween costume contest are also part of the activities.

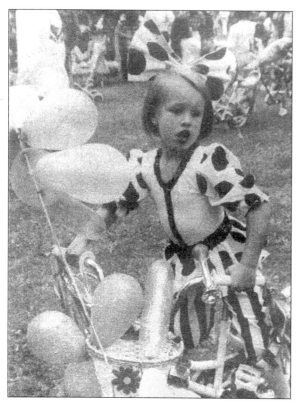

The Maumee Summer Fair has been an annual event for over 20 years. Craft and food vendors line the streets, and entertainment is provided throughout the day. Five-year-old Alexa Hazelton is all decked out to ride her bike in the 1992 parade.

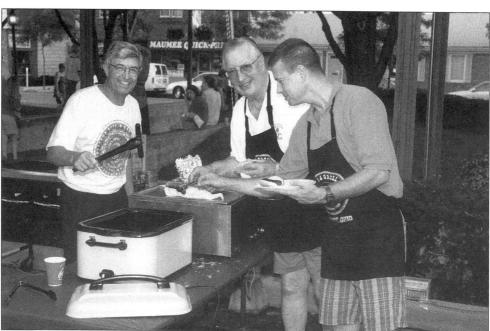

A community fireworks celebration began a new Fourth of July tradition in the 1980s. The fireworks are preceded by a community party with refreshments and entertainment at the Chamber of Commerce lot. Mike Seifert, Howard Tiefke, and Bill Anderson are acting as grill chefs.

Six

FAMILIAR SCENES AND
HISTORIC SITES

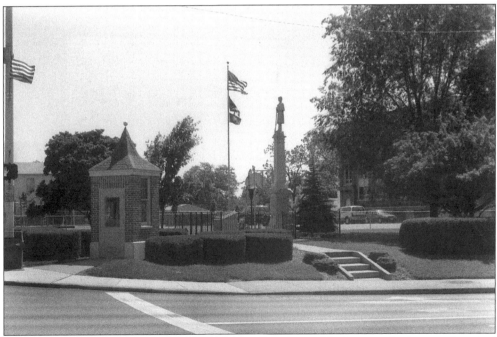

The corner of Conant and E. Broadway Streets has changed little over the last one hundred years. The Soldiers Memorial has stood guard since 1888. The veterans memorial flame was moved to the site in the early 1990s, and the old guardhouse was replaced with a new brick building resembling the early cupola atop Union School.

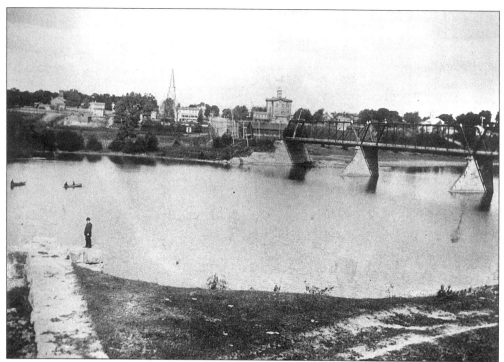

This often-photographed view of Maumee has remained almost intact for over a century, except for the loss of the Methodist Church, left, and the Lautzenheiser Woolen Mill, center. St. Joseph Catholic Church, the John Hunt and Robert Forsythe Houses flanking Conant Street, and the Presbyterian Church are still visible although obscured by heavy foliage in the lower photo, c. 1950. Missing in the lower photo is the cupola from Union School.

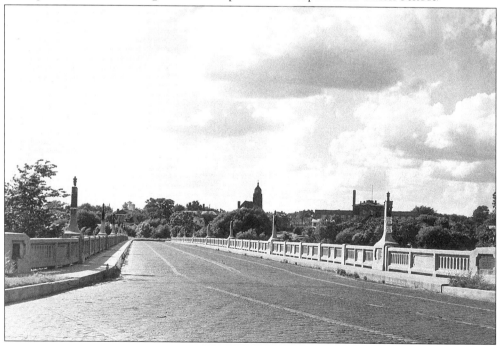

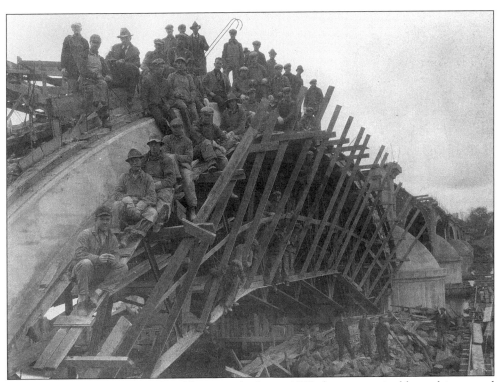

The 1880 iron bridge was replaced by a new bridge in 1928 that was praised by architects and engineers for its innovative construction and design. Workers take a break long enough for a photograph to be taken of the unique arch construction.

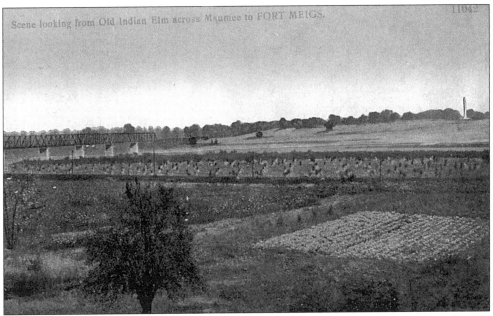

The interurban bridge can be seen with the Fort Meigs monument on the Perrysburg side. The flats were extensively farmed for many years.

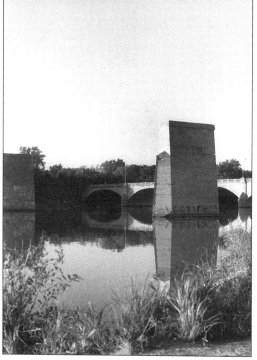

The masonry bridge supports for the old interurban bridge still span the river in this late 1950s photo. The remaining bridge supports, reflected here in the river, have become a part of the traditional Maumee-Perrysburg school rivalry. Each fall, youngsters find ways to scale their steep sides and inscribe graffiti.

The above view looks upriver near Side Cut Park. Below, looking downriver toward Pilliod's Island, a canoe is tied up near the old steamship landing.

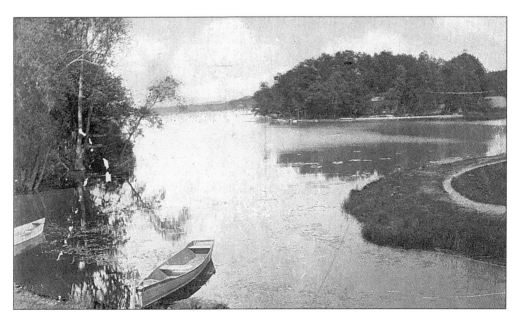

A park was located across from the Commercial Building (here referred to as the Bismark, currently Linck's Inn), where schooners and steamboats once deposited passengers and goods (top). Stan Corl was among the first to build a home on the steep riverfront. He was photographed below in his patio/studio overlooking the old steamboat landing, where he and his wife Sandy, an artist and teacher, often worked.

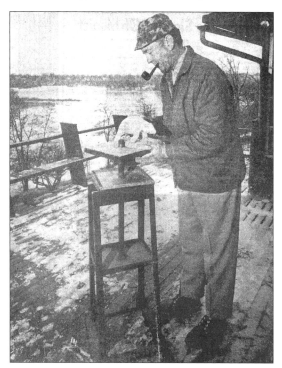

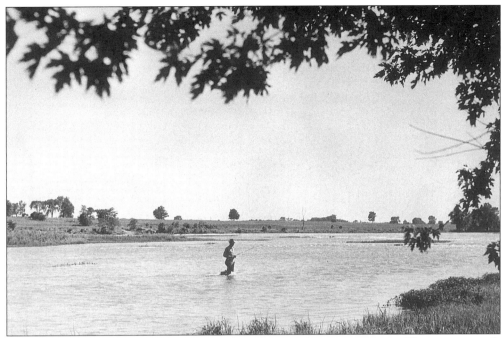

A solitary fisherman enjoys a warm, sunny day fishing in the Maumee River. The scene is much different in the early spring, when hundreds of fishermen—men and women—descend on the Maumee for the annual Walleye Run.

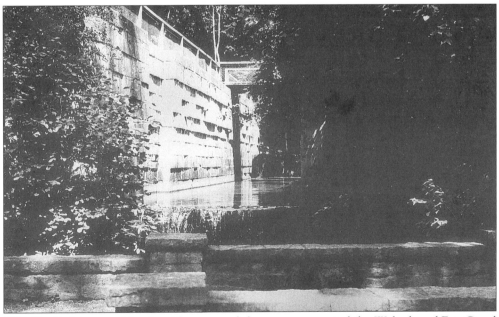

Side Cut Park is named for the side-cut canal that once connected the Wabash and Erie Canal with the Maumee River. The side cut was originally 1.7 miles long, and boats were transported through six massive locks built from stone quarried at Marblehead. Three of the locks remain. The park now provides picnic areas and hiking trails. The Lamb Heritage Center is also located here.

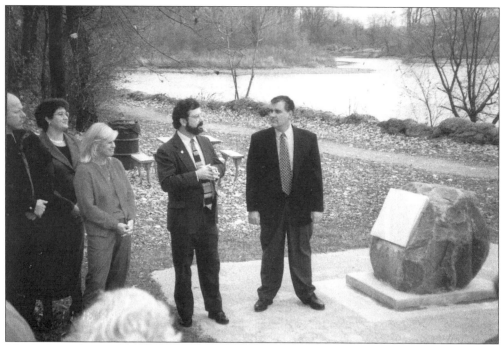

The locks at Sentinel Point, named for its strategic position overlooking the river, are the easternmost connection with the canal within Maumee. A bronze plaque dedicated to three volunteer members of the Parks and Recreation Commission for their time and commitment to the community—Andrew Merrels, Doris Litrell, and William Grieve—is located near here. Shown at the dedication in 1998 are, from left to right: Konrad Kolbow, Karla (Merrels) Lewis, Joyce Olman, Mayor Steve Pauken, and Alex Johnson.

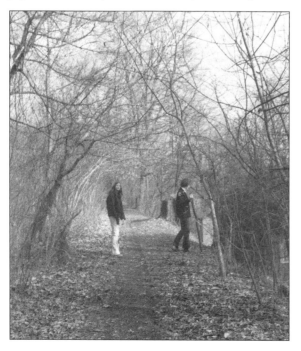

During the canal era, drivers led their mule teams along the towpath, pulling the boats behind them. Today walkers, runners, bicyclists, and nature lovers traverse the length from Sentinel Point to Side Cut Park, where they can connect with the Metro parks and continue westward along the river. Melissa (Wendler) Steinecker and Sam Marsh are enjoying a hike on a sunny fall afternoon in 1973.

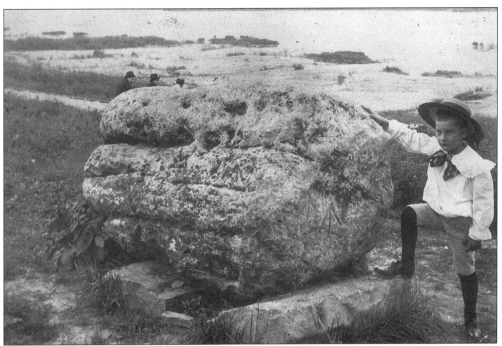

According to tradition, a legendary Ottawa Chief rallied his troops from atop Turkey Foot Rock during the Battle of Fallen Timbers before being struck down by enemy fire. The Ottawa revered his memory by bringing tobacco and inscribing hieroglyphics on its surface. The rock originally was located along the river where this young boy is examining it (above), but was moved across the road and eventually to the top of the hill by the Fallen Timbers monument. Recent ceremonial offerings can be seen (below).

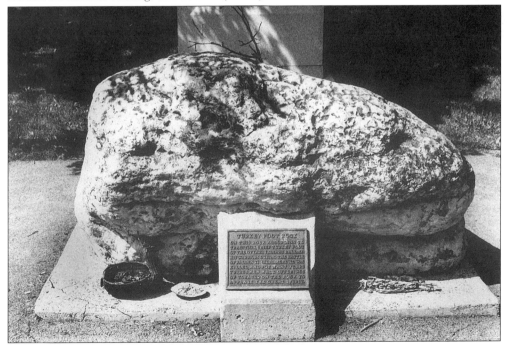

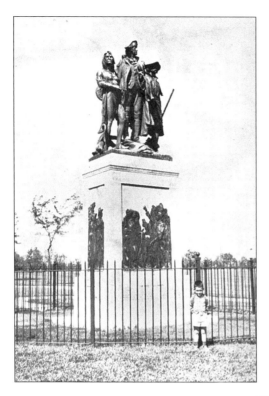

The Fallen Timbers Memorial commemorated the American soldiers who fought under General Anthony Wayne, the Native Americans, who resisted loss of their lands, and the pioneers who settled here. The Battle of Fallen Timbers, in August of 1794, was a decisive turning point in convincing the Indian tribes to sign the Treaty of Greenville in 1795, thus opening the area to settlement. The battle actually spread over a much larger area, recently designated as a National Historic Site.

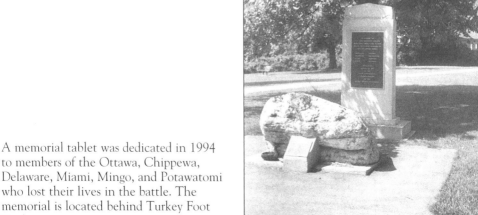

A memorial tablet was dedicated in 1994 to members of the Ottawa, Chippewa, Delaware, Miami, Mingo, and Potawatomi who lost their lives in the battle. The memorial is located behind Turkey Foot Rock.

Fort Miami was built by the British in 1794 to protect their claims to northwest Ohio. After the Battle of Fallen Timbers, the British ceded the fort to the Americans, but it was occupied again by British General Proctor during the War of 1812. The fort was prized for its strategic location, commanding land and water routes. A bronze plaque marks the site (below).

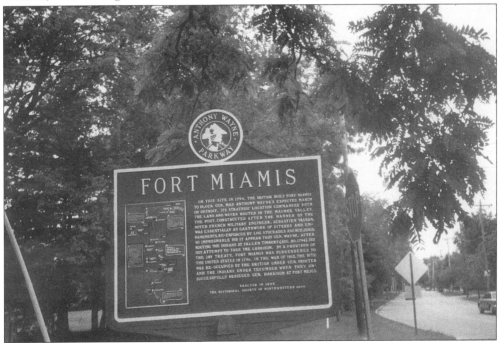

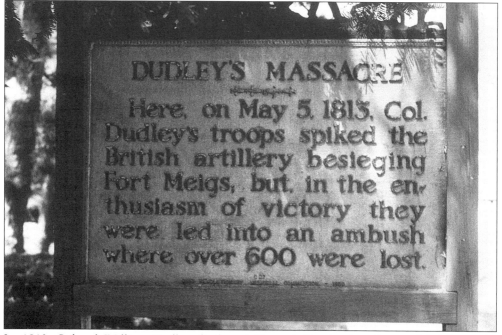

DUDLEY'S MASSACRE

Here, on May 5, 1813, Col. Dudley's troops spiked the British artillery besieging Fort Meigs, but, in the enthusiasm of victory they were led into an ambush where over 600 were lost.

In 1813, Colonel William Dudley disobeyed General Harrison's orders and led his eight hundred Kentucky volunteers after a force of British and Native Americans. The Americans were ambushed, and more than half of Dudley's men, including the Colonel, were killed or taken captive and forced to run the gauntlet at Fort Miami.

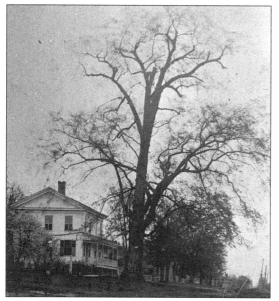

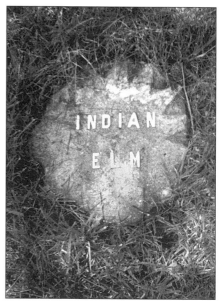

According to tradition, Native American sharpshooters perched in the branches of the legendary Indian Elm to fire on American soldiers at Ft. Meigs. Although threatened by lightning, fire, disease, and the loss of most of its limbs, the elm survived until 1924. Its worst enemy proved to be progress and, in spite of citizen protest, it was ultimately removed to pave Harrison Street (left). To perpetuate the legend, Ralph Day placed this small marker at the elm's location (right).

The Soldier's Memorial was dedicated in 1888, to the memory of the servicemen who lost their lives in the Civil War. Each Memorial Day, residents gather at the monument to read the names of the veterans and those of succeeding conflicts.

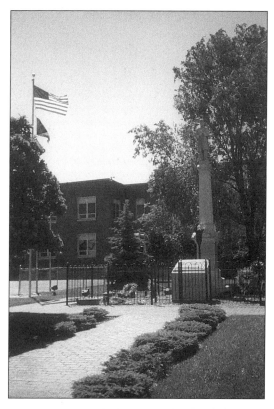

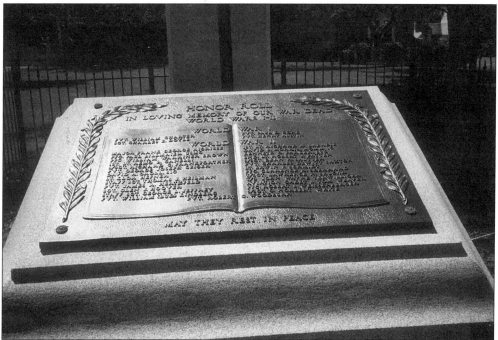

A tablet honoring those killed in the two World Wars, and the "eternal flame" honoring veterans of all wars have been added to the site.

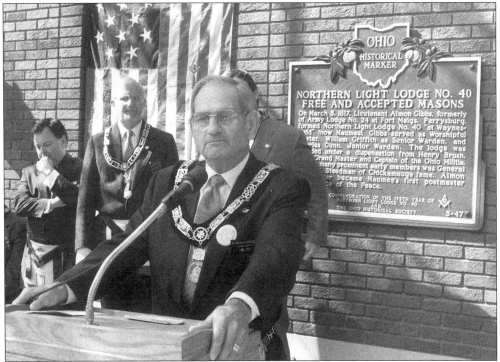

Northern Light Lodge No. 40 received a formal charter in 1818. Among its early members were Almon Gibbs, Horatio Conant, Robert Forsyth, and James Wilkinson. An Ohio commemorative plaque was dedicated in 1992, and placed on the front facade of the Masonic building. Pictured, from left to right, are: Byron Stickles, Larry St. John, and Ohio Grand Master Paul Gerber.

The "lower steamboat landing" at Miami, across from Wolcott House, was the scene of much activity as steamships and schooners came and went, and wholesalers and retailers bargained in the warehouses. Today, the hub of maritime and mercantile activity is a quiet riverfront docking area where pleasure boats tie up at the Indian Hill Boat Club (pictured) and private homes along the waterfront.

Seven

SCHOOLS, CHURCHES, AND PUBLIC BUILDINGS

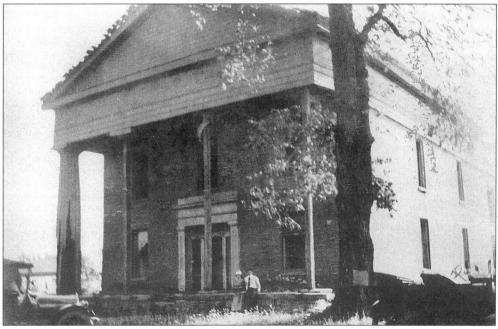

The first Lucas County Courthouse was built on the present library grounds in 1840. Many famous barristers, including President Rutherford Hayes and Morrison Waite, heard cases here in its heyday. When the county seat was moved to Toledo in 1854, the courthouse was converted to commercial use. It served as a seminary, a glass factory, and lastly, a factory for carousel horses. The building was abandoned, and in spite of attempts to save it, was finally demolished in 1919. Carl and Ethel (Summerskill) Wenzel are inspecting the ruins, c. 1917.

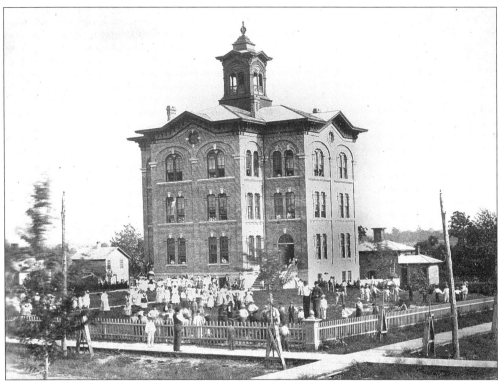

Union School was described as an "architectural showplace" shortly after its completion in 1870. The students are all dressed up for a special occasion, and some peer down from upper windows. The fence lasted only a decade, and the bell tower was removed in 1937. Union served all 12 grades until 1940.

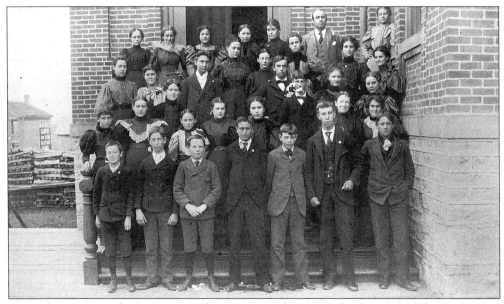

Upperclassmen pose for posterity on the east steps of Union School in 1899. The Pauken rug factory on E. Harrison Street can be seen in the background.

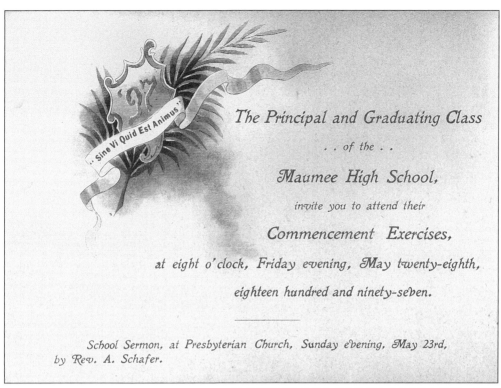

'97

.. Sine Vi Quid Est Animus ..

The Principal and Graduating Class

.. of the ..

Maumee High School,

invite you to attend their

Commencement Exercises,

at eight o'clock, Friday evening, May twenty-eighth,

eighteen hundred and ninety-seven.

———

*School Sermon, at Presbyterian Church, Sunday evening, May 23rd,
by Rev. A. Schafer.*

The program for the 1897 commencement activities filled four pages, although the graduating class, the largest thus far, consisted only of Eva Crain, Eunice Allyn, Leona Gusess, Edith Murphy, Agnes Strain, Elizabeth Myers, Rilla Hull, Josephine Bradford, Katherine Breay, and one boy, Sterling Beeson. At right, Rilla Hull models her graduation dress.

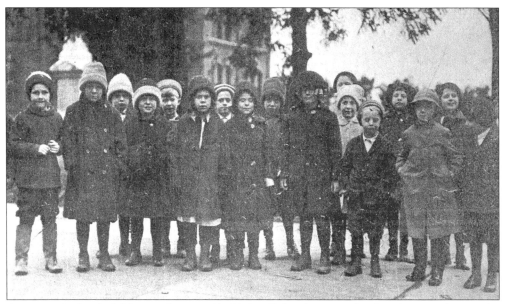

A group of school children gather outside Union School to pose for the photographer in the early 1900s. One boy is sporting a new slicker on this rainy winter day, but the rest are bundled into heavy coats, knee-high boots, and woolen caps.

SUBJECT	TERM										Annual	
	1	2	3	Ex.	Fin.	4	5	6	Ex.	Fin.		
Half Days Absent	0	0	0			0	0	0				
Times Tardy	0	0	0			0	0	0				
Deportment	a	a	a-			a	a	a+				
English	a	a+	a+	95	a+	a+	a+	a+	a+	97		
Literature												
History ⸺civics	a	a	a-	90	a-	a	a	a	Ex	a	a	
Economics												
Psychology												
Science Hy.	a	a	a	98	a	a+	a	a	Ex	a	a	
Mathematics	a	a+	a		a	a+	a+	a	Ex	a+	a	
Algebra						a	a	a	Ex	a	a	
Latin												
French												
Comm'l Arith. Geo	a	a	a-	94	a-							
Bookkeeping												
Agriculture	a	a+	a	90	a-	a+	a	a	Ex	a	a	
Music												
Tests and Measurements												
Courtes		a				a	a					
Monroe Reasoning {Prin. {Conclus. a Rate a		a a				a a- a a-						

Louise Love, daughter of Mayor Calvin Love, excelled in her school studies. This 1920 report card is from Louise's eighth year at Union, when Deportment was still an important part of the curriculum! T.B. Corbett was the principal.

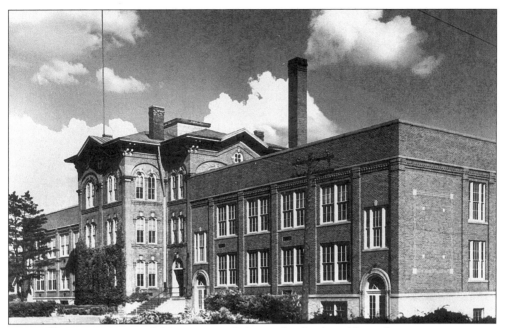

As enrollment was increased, Union expanded accordingly. An addition housing a gymnasium to accommodate the new emphasis on physical fitness was added in 1922. Three years later a matching addition was added to the east side. The third floor was removed and windows were altered "to save heat" in 1952.

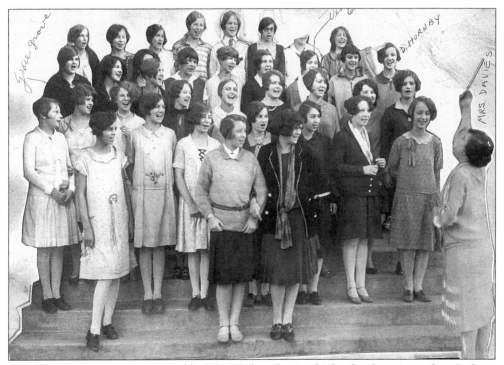

The 1926 girls' chorus was directed by Mrs. Herbert Davies, high school music teacher. Perhaps they were practicing for the historical pageant later that year.

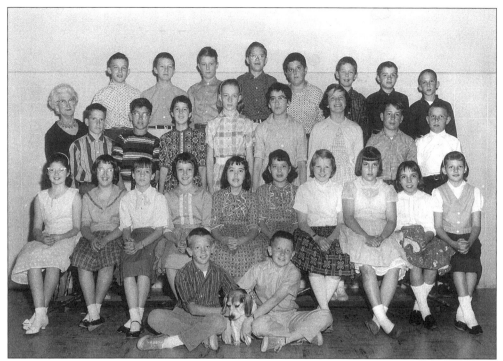

Alta Richardson taught at Union from 1924–1927, but was called back during the wartime teacher shortage in 1942. She retired in 1961, shortly after this class picture was taken. Her teaching methods were sometimes unconventional, such as bringing her dog, Benjie, to class with her each day, but she is credited by several generations of students with being their most memorable teacher.

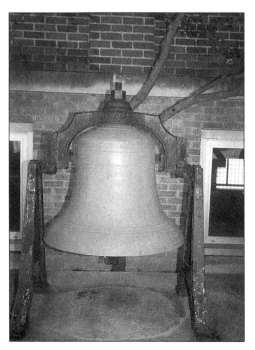

The bell which once hung in the cupola of Union School occupies a place of honor outside the front entrance. During World War II, well-meaning citizens suggested donating the bell to the scrap metal drive. Alta was quick to mount a drive for its preservation.

Mr. Crane, pictured at top left, was a teacher at Fort Miami during the 1890s. On the right, two young girls are off to school carrying lunch buckets and McGufffey readers. Due to lack of space and teachers, classes often shared a classroom. Below, elementary grades one through six pose at Fort Miami, c. 1900.

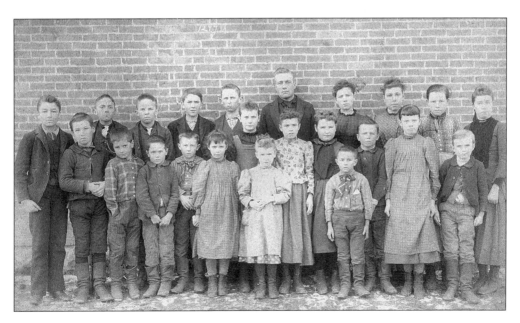

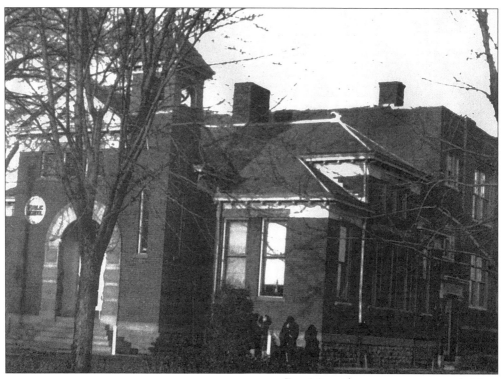

Fort Miami began as a two-room brick school building in 1893. New wings were added in 1922 and again in 1952, when the building was completely remodeled.

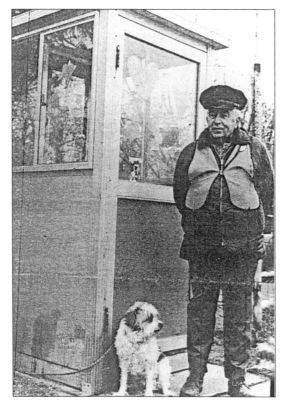

School guards have served both as protectors and friends to several hundred of Maumee's schoolchildren. Their "guard houses" have become familiar sights. Fort Miami guard Henry Hertzfeld, with his faithful companion, Rags, decorated his house for Valentine's Day.

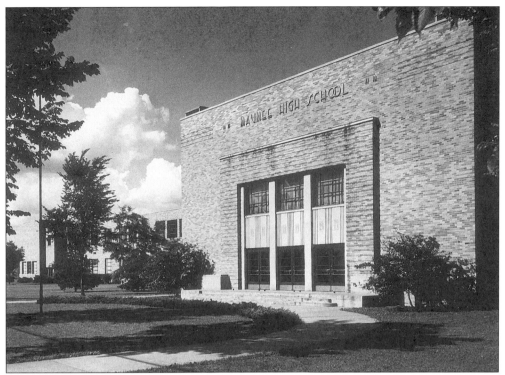

The new Maumee High School at Gibbs and Sackett was completed in 1940 (above). Additions were made in 1956, but the entire school population continued to expand, and a new high school opened its doors in 1961. Pictured below are Peggy Conrad, student council president, and Dan Condron, vice president, at the entrance to the modern facility.

Participants in the Children's Theater Summer Workshop, a program of the Maumee Schools and the Maumee Recreation Department, met daily in the middle school during the 1970s. A highlight for these students was a session with actress Jane Powell, starring in a 1975 theater production at the Masonic Auditorium.

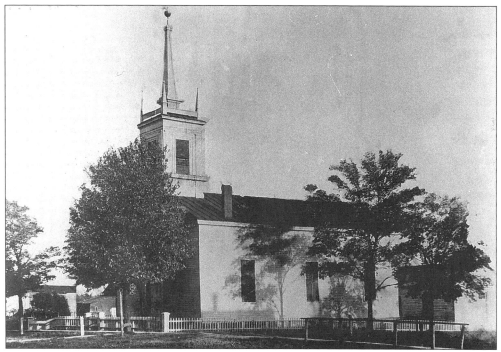

The oldest remaining church in the Maumee area is the Presbyterian Church, built in 1837. Early elders included Horatio Conant and Levi Beebe, builder of the Commercial Building. Since the completion of a new adjacent church, the older building has served as a chapel.

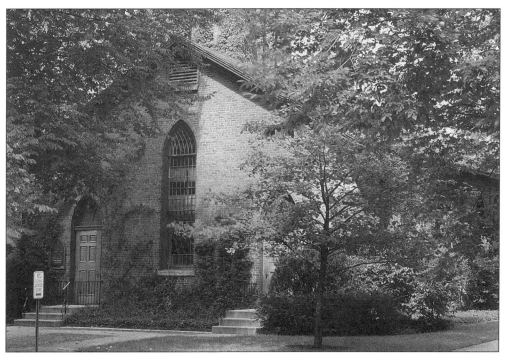

St. Paul's Episcopal Church is the second oldest remaining church. It was built in 1843 on land donated by James Wolcott and several others. The four original spires on the Gothic bell tower were removed for safety reasons. St. Paul's is one of the few remaining examples of Gothic architecture in Maumee.

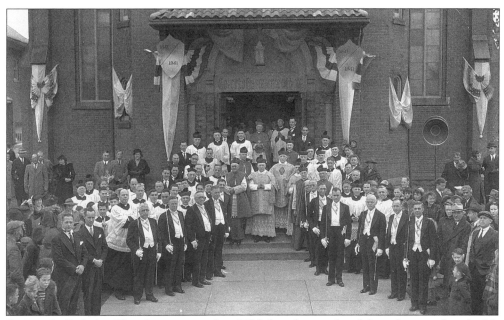

St. Joseph Catholic Church was erected in 1888, but the parish celebrated its one hundredth year in the Maumee Valley in 1941. Visitors, parishioners, and visiting dignitaries line up outside the front entrance.

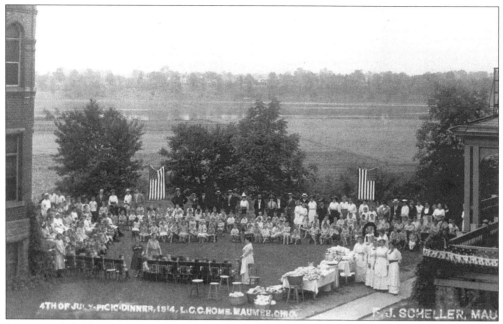

A group of children gathers on the lawn to enjoy a Fourth of July picnic at the Lucas County Children's Home, constructed in 1890 to accommodate the growing number of homeless and destitute children.

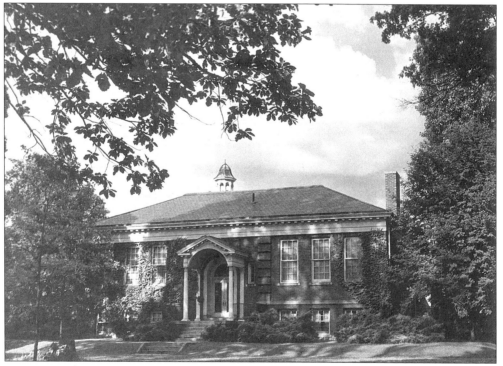

Maumee residents were justly proud of the Maumee/Lucas County Library, constructed in 1917, although many regretted the loss of the neighboring courthouse. The library is now part of the Toledo/Lucas County Library system and is undergoing a major expansion in 2000.

The first Lucas County Fair buildings were constructed in 1918. The grandstand was built that year to accommodate the many harness racing fans at the "Maumee Downs Race Course," and was host to the "Grand Circuit" for many years. The grandstand was later converted to a stadium for the Toledo Mud Hens.

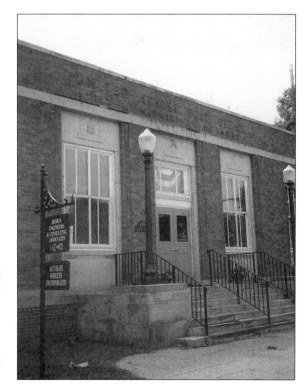

A modern, new U.S. Post Office was constructed in 1937. The three symbols on the front facade reminded customers that the mail could now be carried by rail, by ship, or by airplane. In the interior, a large patriotic mural (considered by some to be risque for its time) symbolized the growth of America. This building served the public until 1999.

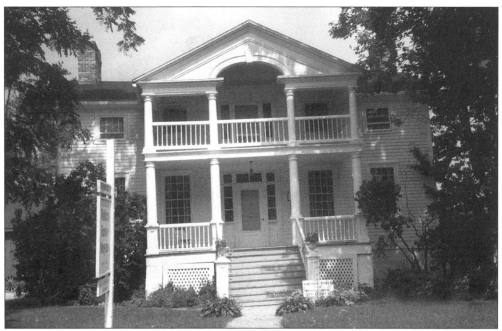

The Wolcott House, the original building on the Wolcott Historical Complex grounds, was built by James and Mary Wells Wolcott in 1830. Interpreted as a House Museum, it is an important historical, architectural, and educational asset to Maumee and the entire Maumee Valley (above). The complex has grown to include seven historical buildings. A favorite is the Log House, which once sat on the banks of the canal. The Log House provides docents an opportunity to describe pioneer life in the valley (below).

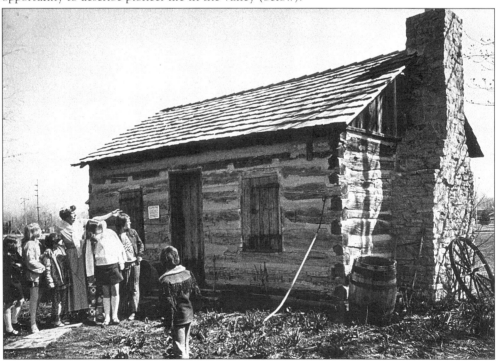

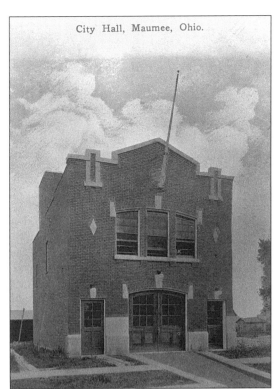

City Hall, Maumee, Ohio.

The Maumee City Hall in 1913 housed all the activities of city government, including fire and police facilities (at right). By 1940, a new building, a "model of efficiency," was constructed with separate offices for clerk, mayor, and council. Additions to accommodate council and court were built later, but the expansion of municipal services eventually outgrew this facility.

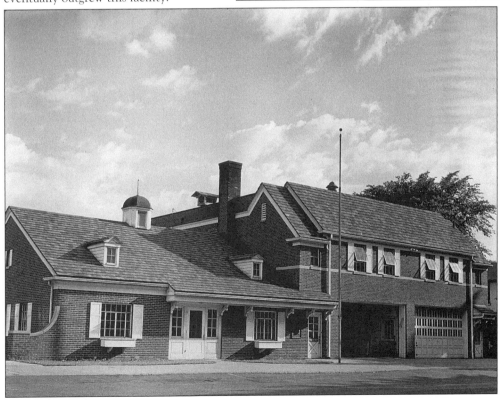

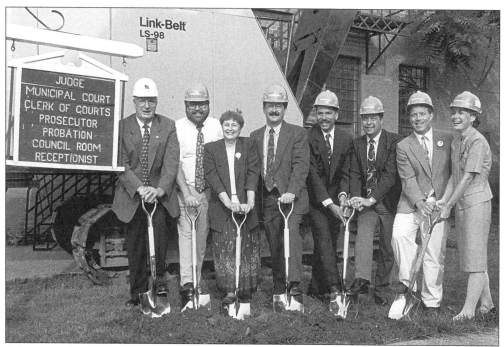

After several years of planning, ground was broken for a new Municipal Building in August of 1995. Manning the shovels are, from left to right: Howard Teifke, Tim Wagener (later mayor of Maumee), Barbara Dennis, Mayor Steven Pauken, Chris Ferrara, Rick Maier, Tom Shook, and Jenny Barlos.

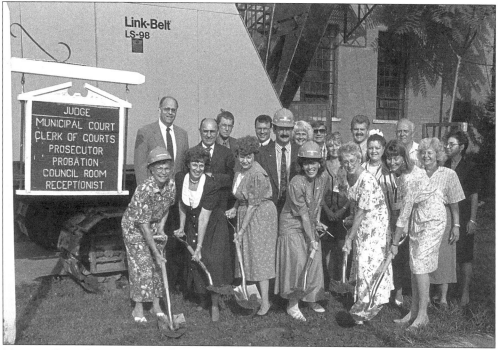

Maumee City administrators and staff join the groundbreaking.

Eight

BOATS, BUGGIES, AND TRAINS

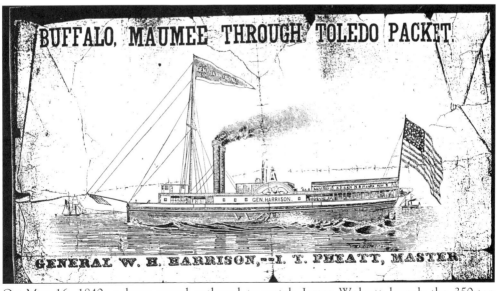

On May 16, 1840, a large crowd gathered to watch James Wolcott launch the 350-ton steamboat named in honor of General Wm. H. Harrison, and appropriately decked with Whig symbolism, from his shipyard near the lower steamboat landing. The launching of a ship such as this caused great civic pride and celebration.

For centuries, a primitive route stretching north to Detroit and east to Pittsburgh, known as the Great Trail, was traveled by Native Americans, French traders, and British soldiers. It was later extended to follow the Maumee River west to Fort Wayne, Indiana.

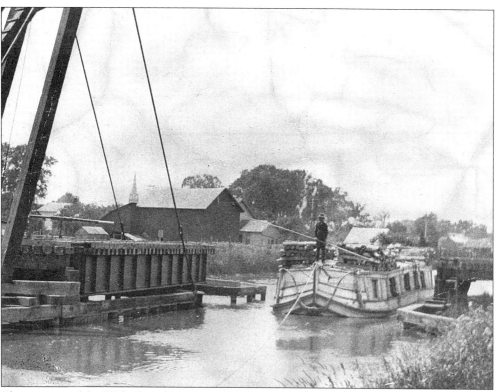

The opening of the Wabash and Erie Canal brought a short-lived prosperity to Maumee. Canal boats were prime carriers of goods and passengers until the 1850s, when the railroads proved to be faster and more efficient.

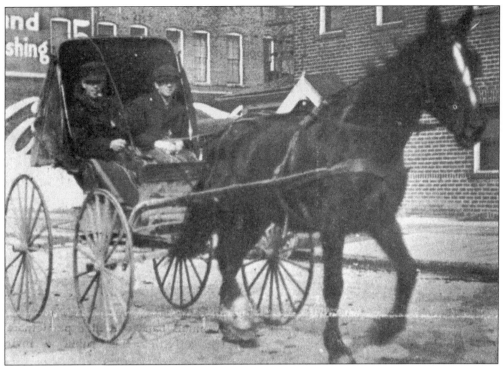

Two young men in a surrey cut the corner at Conant and Wayne Streets. Nearly every family kept a horse, buggy, and horse barn until well into the 20th century.

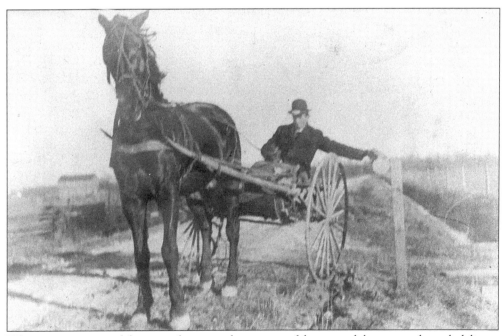

When necessary to deliver mail, it was by means of horse and buggy, and rural delivery remained horse-powered through the early 1900s. Carrier George Ragan, shown making his rounds, had to provide his own transportation.

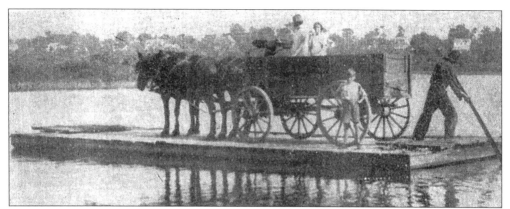

Louis Pilliod used an age-old conveyance, similar to the early ferries which carried passengers and livestock, to reach his farm on the island until well into the 20th century. Many a youngster hitched a ride.

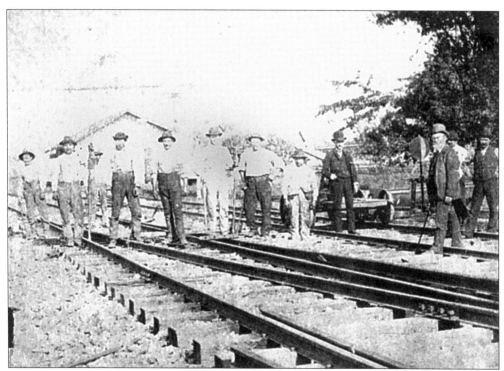

In 1887, the Toledo, St. Louis, and Kansas City Railroad (known as the "Clover Leaf") converted its tracks from narrow gauge to standard. Over two hundred men—employees and railroad enthusiasts—worked overnight to keep service uninterrupted. The Clover Leaf Depot is in the background.

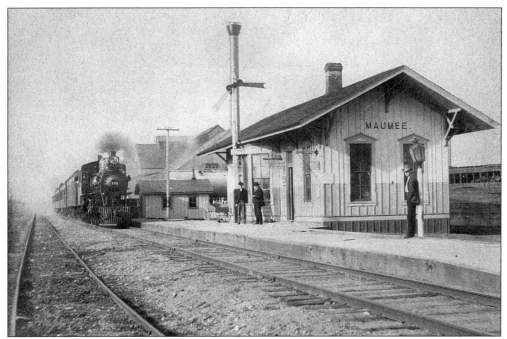

Passengers are waiting to board the train at the Nickel Plate (Clover Leaf) Depot, built in 1880 to accommodate Maumee's busy train traffic. The depot was located at the corner of Conant and Sophia. It was donated to the Historical Society and moved to the society's complex in 1971.

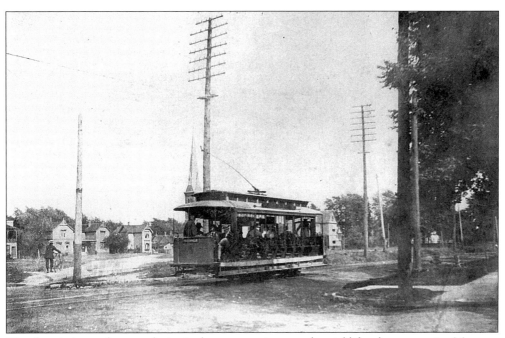

The electric interurban revolutionized transportation—and social life—by connecting Maumee residents with the outside world. This car is open to provide passengers, sitting on wooden benches, with a cooling breeze on a hot summer day.

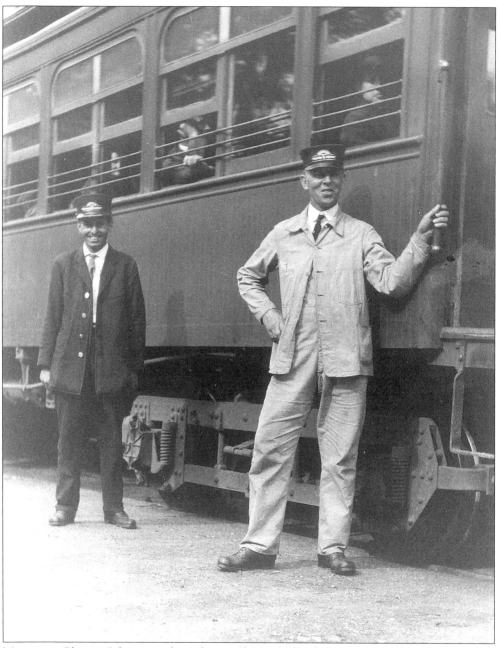

Motorman Clayton Johnson and conductor Christy Miller help passengers board the Toledo, Bowling Green, and Southern interurban car at Maumee in 1916.

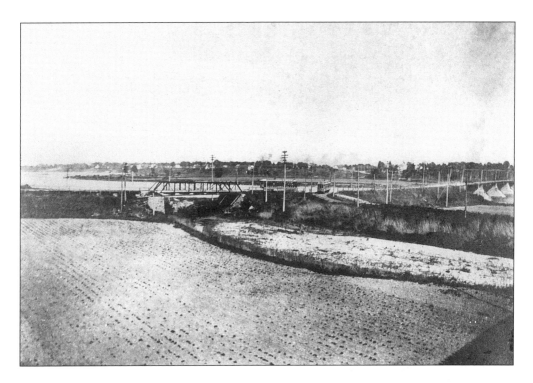

Two cars can be seen after crossing the bridge in tandem from Perrysburg. One is headed toward Maumee (above), while the other is turning toward Waterville following the "pumpkin vine" route.

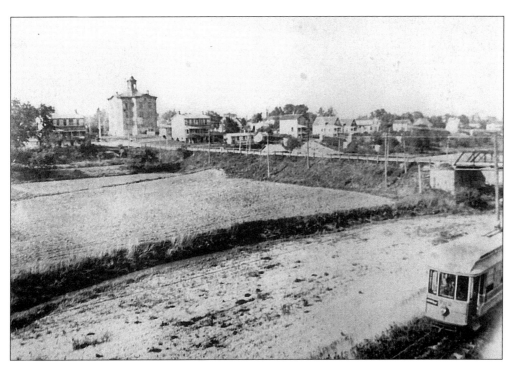

The first station for the Maumee Valley Railway and Light Co. was at Hatch's Lunch Room on the corner of Conant and Broadway. A round-trip ticket to Toledo cost 25¢, but one could travel within city limits for a nickel.

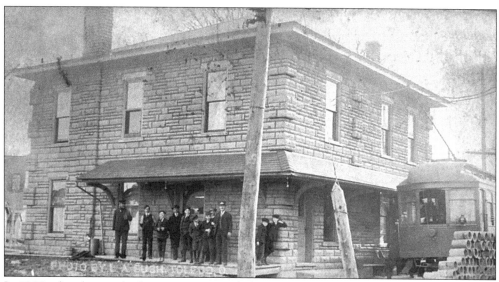

In 1908, after the new bridge was constructed, the Toledo, Bowling Green, and Southern built a modern station at the corner of Dudley and Allen Streets. Both buildings are still in use. Jocky's Depot and Station Shop Antiques Shop occupy the building.

Nine
DISASTERS
NATURAL AND MANMADE

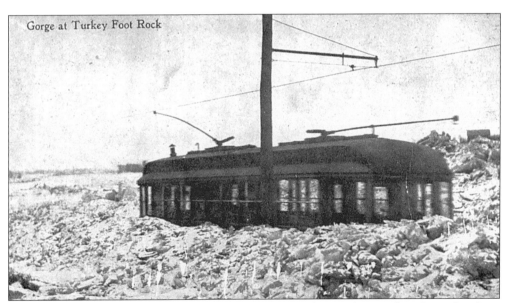

Gorge at Turkey Foot Rock

A winter storm has stranded this interurban car in a sea of ice and snow along River Road.

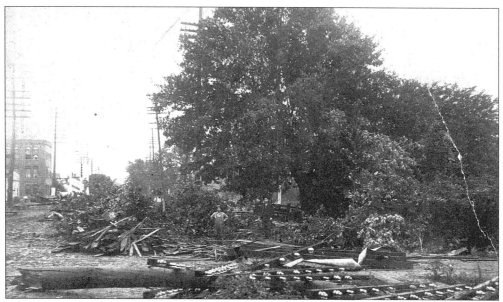

Tornadoes have occasionally ripped through Maumee, leaving a trail of destruction. The site of the Battle of Fallen Timbers was the scene of a tornado in 1794. Another, in 1838, completely destroyed the five-story Commercial Hotel. A 1905 tornado (above) uprooted everything in its path, including trees and telephone and electrical poles. Photographers were as zealous about documenting the damage as they are today. The ancestral home of James and Mary Wolcott (below) appears to have been photographed after the 1905 storm. The roof and shutters show extensive damage.

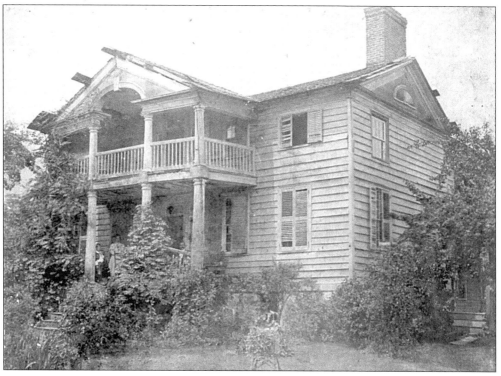

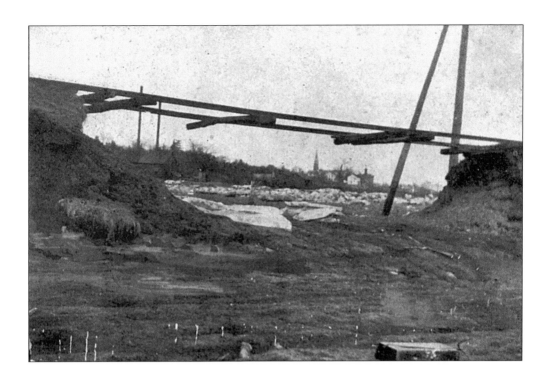

Floods created by melting snow and ice have plagued the Maumee Valley for centuries. River Road provided no barrier to the huge ice floes as they swept across the electric car tracks between Maumee and Waterville. In the above photo, the melting ice can be seen in the background. Many of the monuments at Riverside Cemetery have been damaged by the ice floes over the years, as seen below.

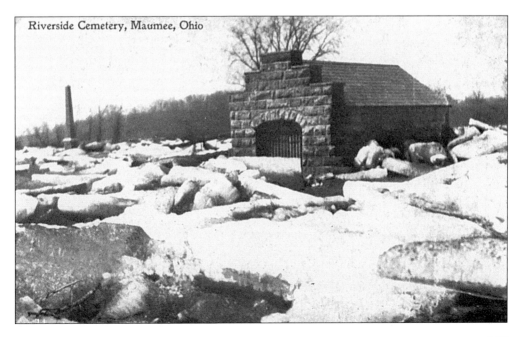

Riverside Cemetery, Maumee, Ohio

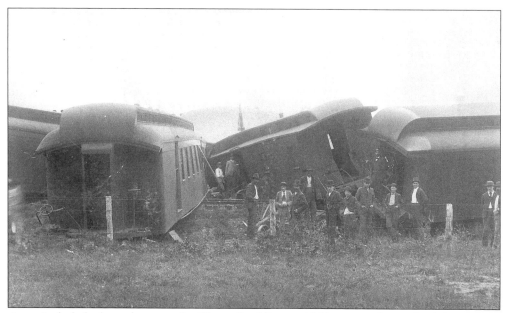

A particularly bad smash-up on the Clover Leaf line in 1894 attracted crowds of the curious. Pictured, from left to right, are five unidentified men, (?) Farthing, John Pauken, Carl Rodd, Tom Steinbeck, unidentified, unidentified, Peck Griswald, and Fred Jennings. The engineer and fireman were killed, but the passengers escaped serious injury.

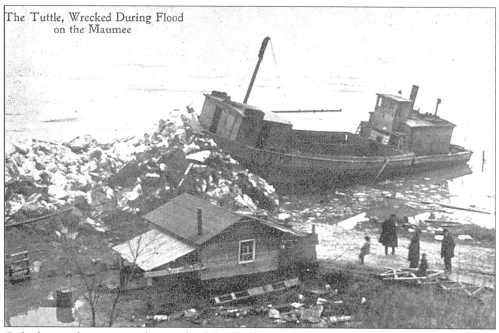

Onlookers gather to view the wreck of the *Tuttle*. Small ships were often helpless against the ravages of the floodwaters.

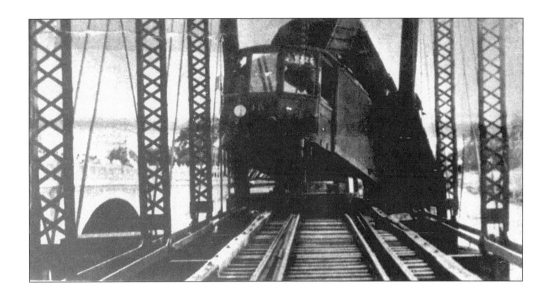

The interurban line suffered its worst disaster when a portion of the iron bridge collapsed in 1936, and the Toledo, Bowling Green, and Southern car went off the tracks. Looking toward Perrysburg, the engine is visible (above), and a car dangles perilously from the bridge (below).

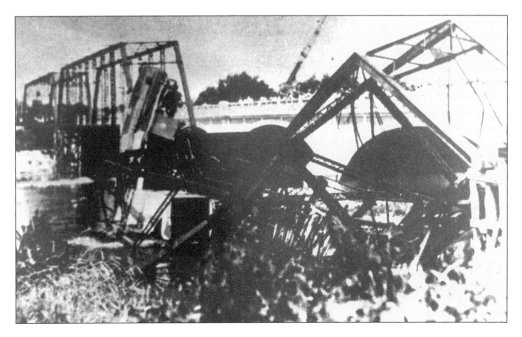

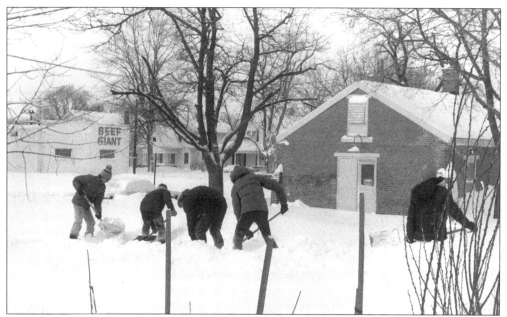

In 1978, the worst storm to ever hit northwest Ohio immobilized the city. Twelve inches of snow fell between January 26 and January 29, and blizzard winds covered the streets with drifts several feet high. Residents work together to clear a path to the street.

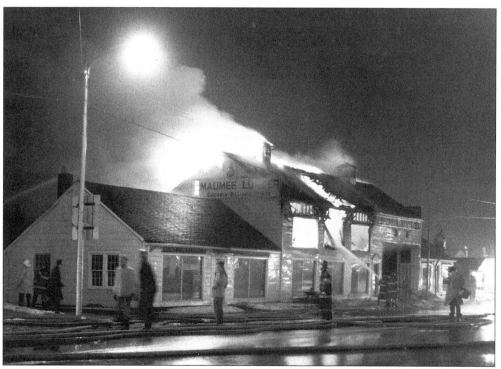

Fires are not new to Maumee. A July Fourth blaze in 1896 leveled the northwest corner of Conant and Wayne. This spectacular blaze destroyed the Maumee Lumber Company in the 1960s.